SOUTH AFRICA

17th May 2010

Dearest Liz & David —

Welcome to South Africa
& Best Wishes for your

Stay in Johannesburg and
Cape Town.

Peter Lombard and the WUSA Team.

SOUTH AFRICA

A visual tour through its regions

SUNBIRD PUBLISHERS

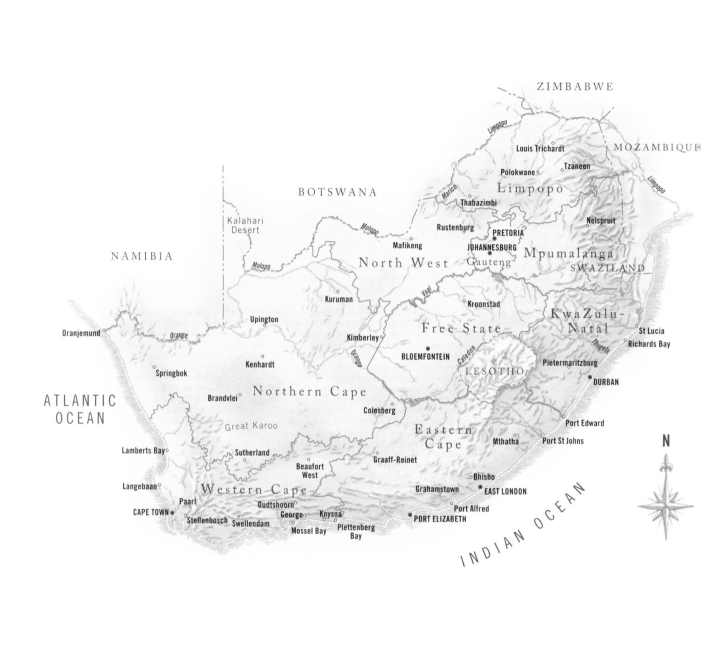

Contents

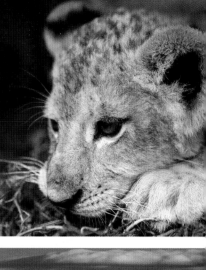
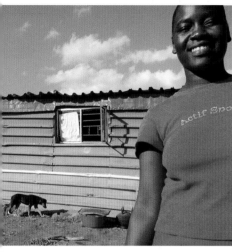
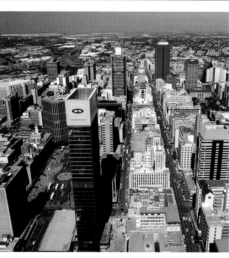
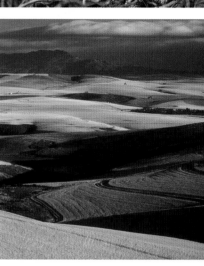
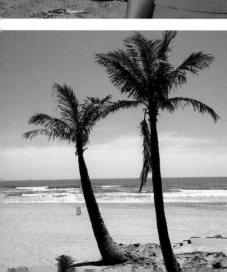
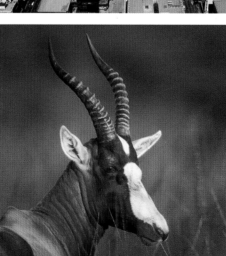
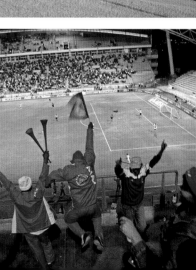

South Africa

For all the diversity of the African continent, no other African country comes close to South Africa's engaging mix of interesting people, varied landscape, pleasant climate and abundant wildlife.

Close on 50 million people are spread throughout the country's nine provinces and though English is widely spoken, ten other official languages – and many more unofficial ones – can be heard in the cities, towns and rural areas. This means there are diverse cultures to explore, a tantalising array of dishes to sample and many a traveller's tale to be borne from the fascinating people you will meet along the way.

And its people have come from everywhere. From the First People, the Bushmen and their descendants, the once pastoral Khoi, the Nguni-speaking groups such as the Xhosa and the Zulu, the Bantu-speaking groups such as the Sotho and the Tswana and the European settlers – primarily Dutch, French and British – who followed in the wake of Portuguese explorers such as Diaz and Da Gama, South Africans have moulded a complex national identity within which all the different groups have found a home.

The landscape is almost as hard to pin down, for it may all be contained within the same borders, but in appearance it is wildly different. Having just left the subtropical valleys of KwaZulu-Natal you can be traversing a mountain pass in the spectacular Drakensberg range and half an hour later roll into the gentle grasslands of the Highveld. Crossing any of the equally formidable Cape fold mountain ranges such as the Swartberg likewise lets you out onto the vast, arid expanses of the Karoo semi-desert.

OPPOSITE FROM LEFT TO RIGHT:

- Vineyards at Delheim outside Stellenbosch in the Western Cape.
- A Pedi woman carrying a bag of firewood near the Blyde River Canyon in Mpumalanga.
- A lion cub at the Seaview Lion and Game Park near Port Elizabeth, Eastern Cape.
- A Venda woman outside her home near Thohoyandou, Limpopo.
- The view from the Carlton Centre over downtown Johannesburg, Gauteng.
- Wheat fields in the Overberg region, Western Cape.
- The so-called Golden Mile beachfront in Durban, KwaZulu-Natal.
- Blesbok, KwaZulu-Natal.
- Ajax Cape Town fans celebrate during a soccer match against arch-rivals Kaizer Chiefs at Athlone Stadium, Cape Town, Western Cape.

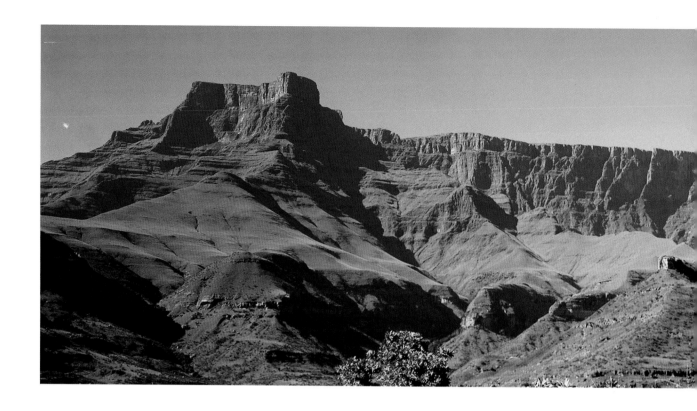

Off the Cape of Good Hope's mountainous seascapes you can see southern right whales cavorting during mating and calving season while much further inland, in Limpopo province, it's the Big Five game – elephant, rhino, lion, buffalo and leopard – that draw the crowds and the clicking cameras.

If you are looking for a relaxing, sun-soaked beach holiday, South Africa's 2 800 km of coastline offers everything from safe bathing beaches to wild, rocky coastlines where anglers will feel right at home. With legendary national parks such as the Kruger and the Kgalagadi Transfrontier Park as well as a host of smaller provincial and private reserves, it is easy to get up close and personal with big game such as lions, elephants and rhinos.

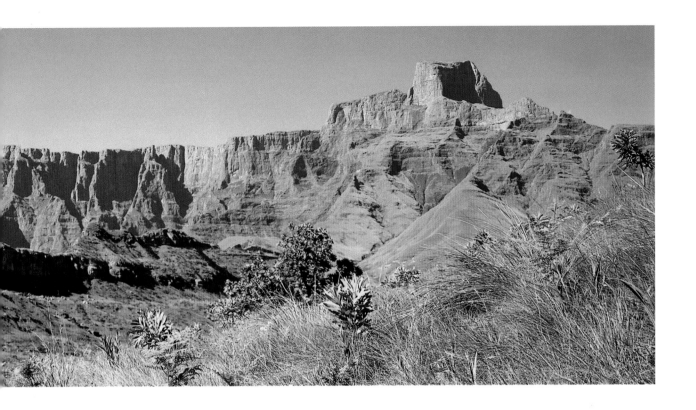

There are eight World Heritage Sites in South Africa, ranging from those of cultural and historical significance such as Robben Island, the Cradle of Humankind (Sterkfontein's hominid fossils) and Mapungubwe to the Richtersveld and the Cape floral region for their plant life, iSimangaliso Wetland Park (birds, wildlife) and the scenic splendour of the uKhahlamba Drakensberg Park.

This book celebrates all the grand glory of the landscape, but also the moments in between, when seasons change in the Winelands, when farmers turn homeward in the Klein Karoo and when hippos in the Letaba River start grunting their approval at the onset of evening.

ABOVE: Mont-aux-Sources is one of the most spectacular sections of the Drakensberg. Situated right on the border between KwaZulu-Natal and Lesotho, the 3 000 m high massif harbours the headwaters of the Vaal, Orange and Tugela rivers. The section is also called the Amphitheatre, referring to the shape of the formation and the valley it embraces below.

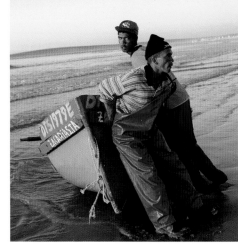
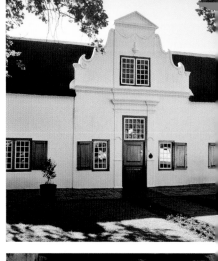
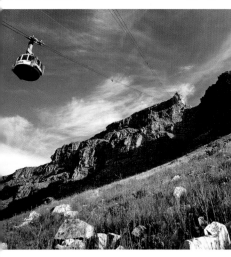
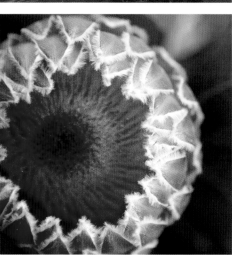
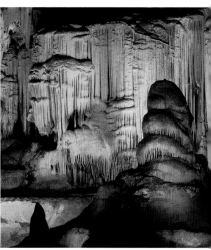
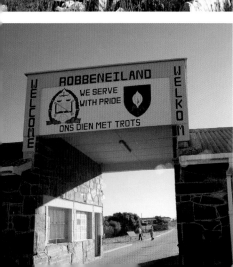
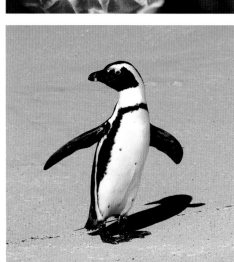
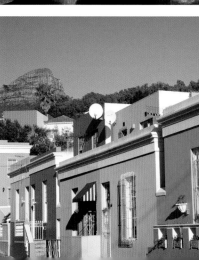

Western Cape

With Table Mountain's iconic outline as its backdrop, the city of Cape Town is almost synonymous with a visit to South Africa. There is certainly much to attract your attention, with the white sand beaches of Camps Bay and Clifton barely ten minutes from the city centre, stunning scenic drives all round the peninsula, and the historic World Heritage Site of Robben Island (its most famous political prisoner was Nelson Mandela) to explore.

Most of the Western Cape's more than five million inhabitants live on the Cape Flats, the broad piece of land linking the mountainous peninsula with the interior. Then, suddenly and amidst both working-class neighbourhoods and perfectly manicured golf estates, the Winelands start. Stellenbosch, Paarl and Franschhoek are the premier wine-producing towns.

The province is one of the world's finest land-based whale watching sites, with towns such as Hermanus, Struisbaai and Witsand attracting large numbers of especially southern right whales during mating and calving season (July to November).

With heavy winter rainfall, this part of the province has an almost Mediterranean climate with wet winters and dry summers, unlike the interior of the country, which relies on summer rains. Once you move deeper into the province – beyond the Cederberg and over the Hex River mountains – the climate changes, becoming the arid Karoo.

If you drive northwards along the coastline from Cape Town you will discover the West Coast, famous for its quaint fishing villages and the rich bird life of the Langebaan lagoon.

OPPOSITE FROM LEFT TO RIGHT:

- Changing rooms at Muizenberg, a popular bathing and surfing beach on False Bay.
- Fishermen at Paternoster on the West Coast.
- Burgerhuis, Stellenbosch – a good example of the Cape Dutch style of architecture.
- A quick ride to the top of Table Mountain by cable car.
- The Western Cape is famed for its fynbos vegetation of which the various species of protea are some of the boldest examples.
- The Cango Caves are at the base of the Swartberg mountain range outside the town of Oudtshoorn.
- The entrance to the Robben Island jail, where Nelson Mandela was imprisoned for 18 years.
- African penguins have a breeding colony at Boulders Beach in Simon's Town.
- Colourful houses on Chiappini Street in Cape Town's Bo-Kaap neighbourhood.

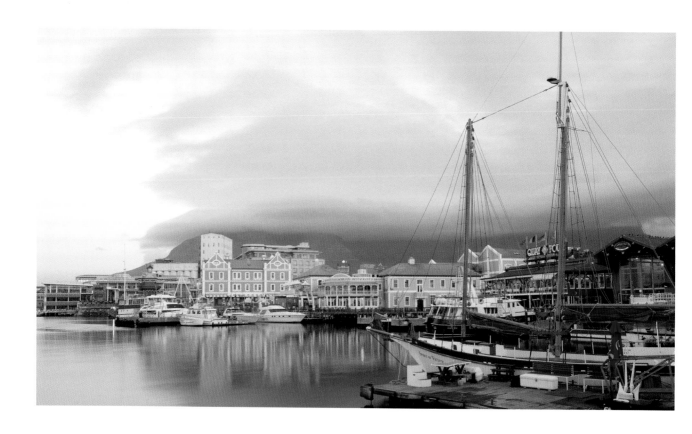

ABOVE: Tourist boats depart for Robben Island from the Victoria & Alfred Waterfront. The Waterfront has grown extensively since its development in the late 1980s to become the most visited attraction in South Africa.

RIGHT: Cape Town's icon, Table Mountain, from across Table Bay at Blouberg Beach.

But follow the south coast, past Africa's southernmost tip at Cape Agulhas, towards Knysna, Wilderness and Plettenberg Bay – this region is known as the Garden Route – where the thick indigenous forests and beautiful secluded bays are in lush contrast to the West Coast's drier climate.

The Cape floral region (another World Heritage treasure) is concentrated on the Cape peninsula and the adjacent mountains to the interior and is home to a staggering 3% of all the planet's plant species. These fynbos (literally: 'fine bush') species include the well-known protea family and can easily be seen during day walks on Table Mountain.

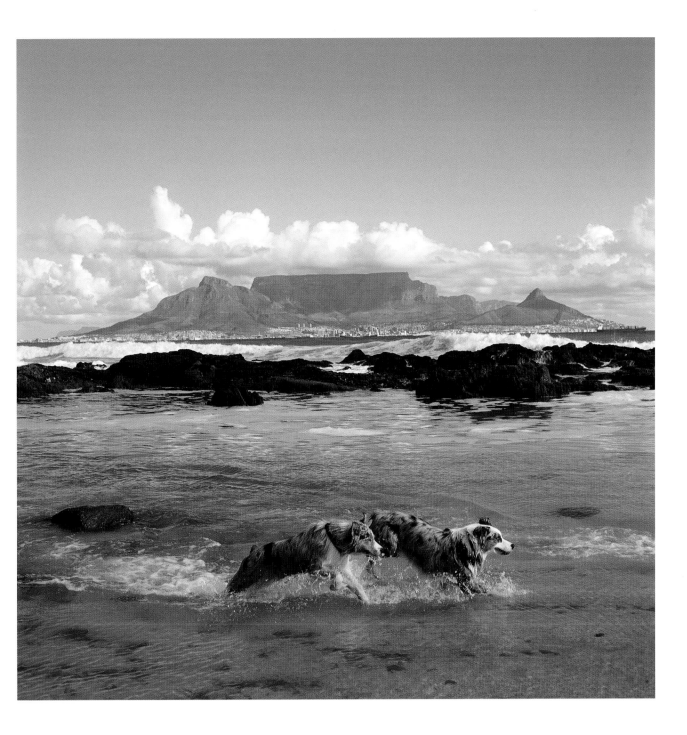

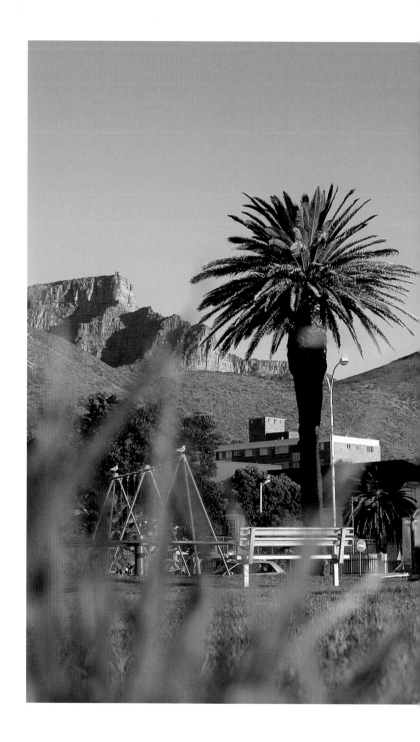

RIGHT: The Sea Point Promenade is a popular public recreation area. Lion's Head and Table Mountain are visible in the background.

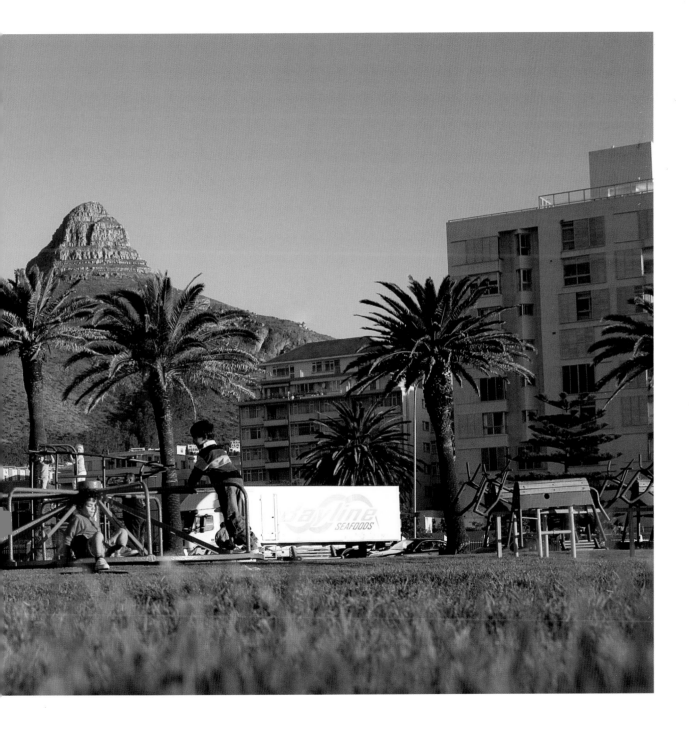

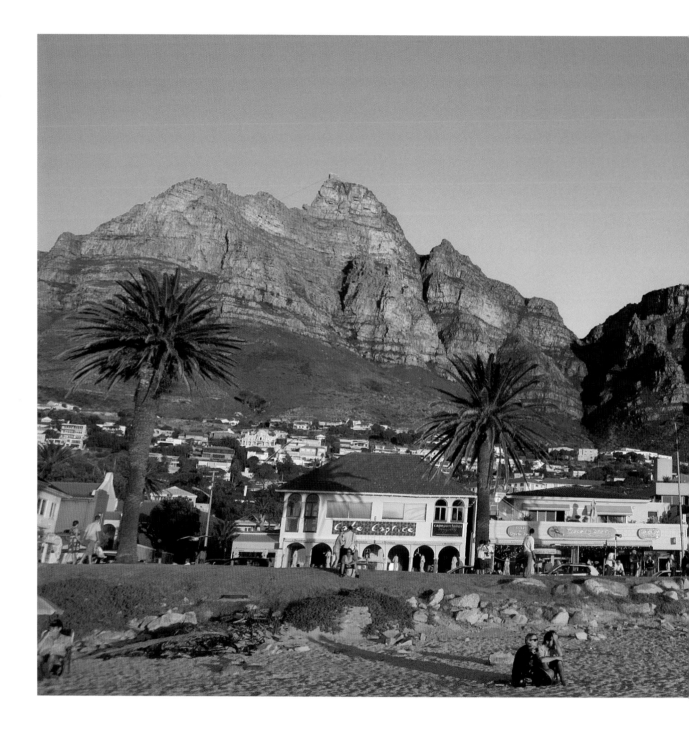

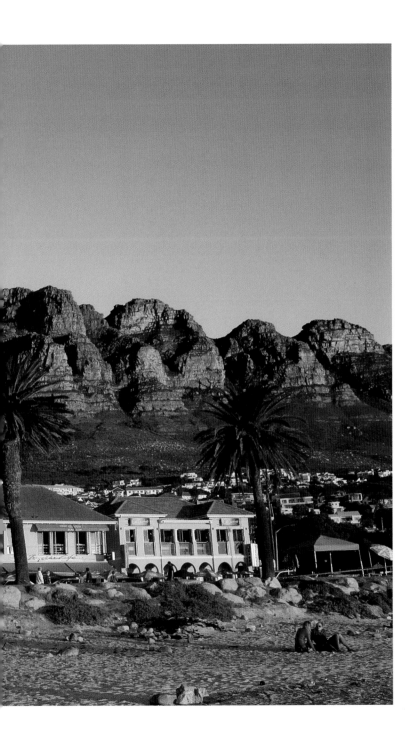

LEFT: The imposing buttresses of the Twelve Apostles overlook Camps Bay.

17

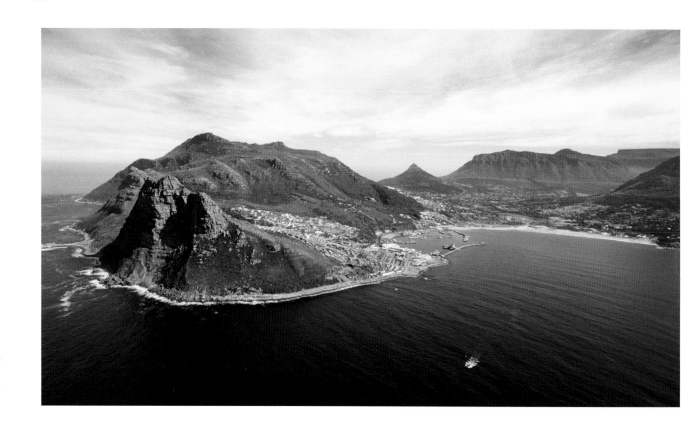

ABOVE: The valleys above Hout Bay yielded much of the wood (*hout* is Afrikaans for 'wood') needed for construction during the early days of the Dutch colony at the Cape. The prominent mountain to the left is The Sentinel. Beyond it, offshore, lies Dungeons, the only Big Wave surfing site in South Africa.

RIGHT: The beach near the start of Chapman's Peak Drive in Hout Bay.

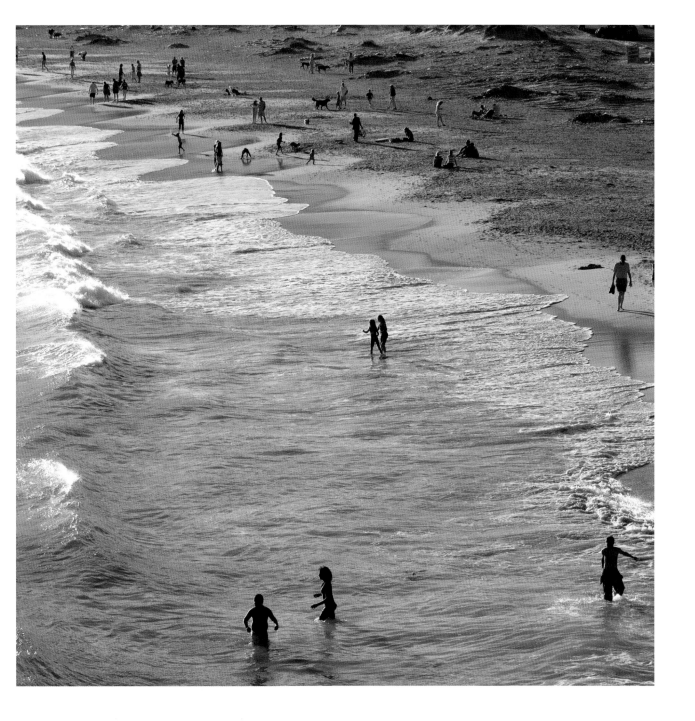

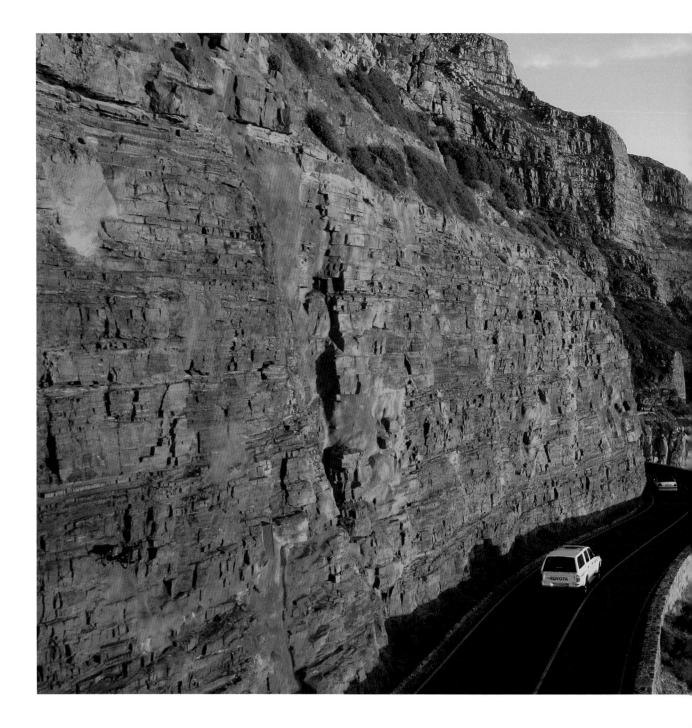

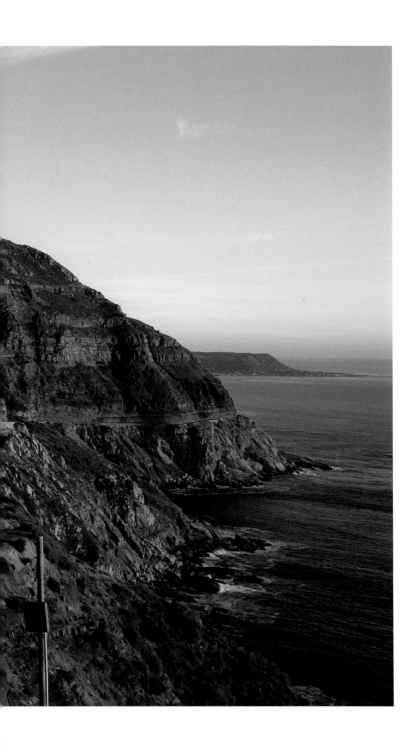

LEFT: Constructed between 1915 and 1922, the stunning Chapman's Peak Drive is carved into a sheer cliff face between Hout Bay and Noordhoek. The road is often closed due to dangerous road conditions and potential rock falls despite extensive renovations in recent years.

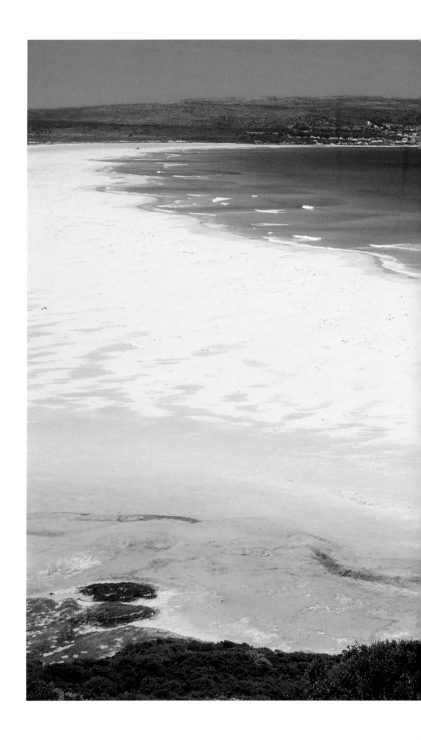

RIGHT: A view from Noordhoek's beach towards Long Beach and Kommetjie in the distance, where the Slanghoek lighthouse stands as sentinel.

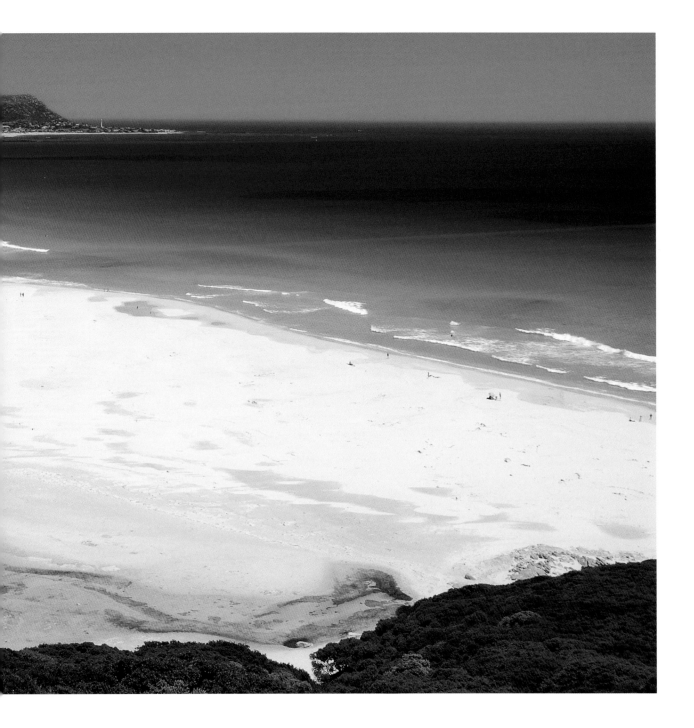

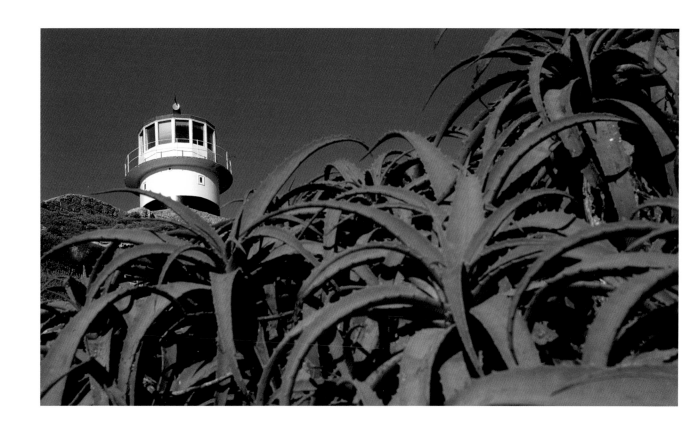

THIS SPREAD: Portuguese explorer Bartolomeu Diaz and his crew were the first Europeans to round the tip of Africa when they passed the Cape of Good Hope and Cape Point during a storm in January 1488. The old lighthouse (above) was replaced by a new one closer to the sea level as it often misguided ships trying to round the cape.

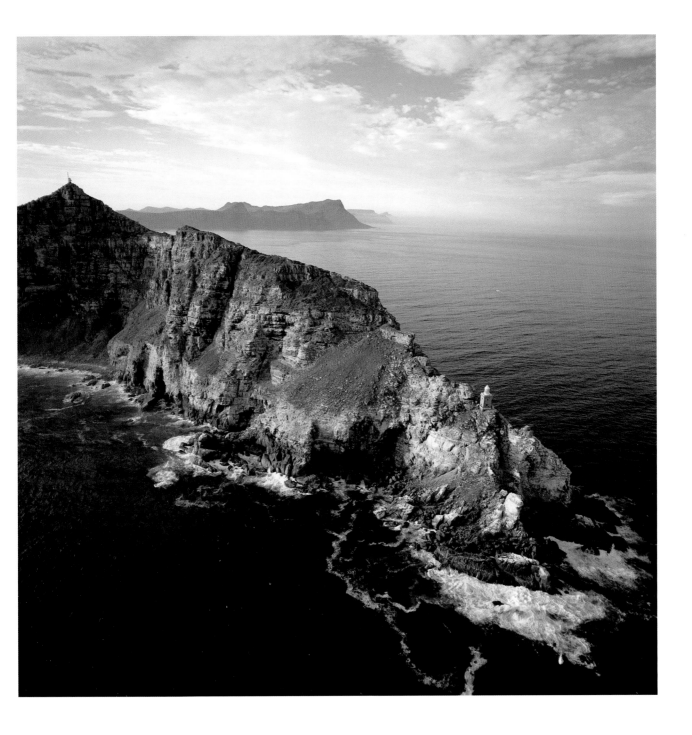

THIS SPREAD: The Kirstenbosch National Botanical Garden harbours plants from all over South Africa such as a variety of aloes (above) and giant tree ferns situated at Colonel Bird's Bath (right). The Gardens contain more than 2 500 plant species from the Cape Peninsula.

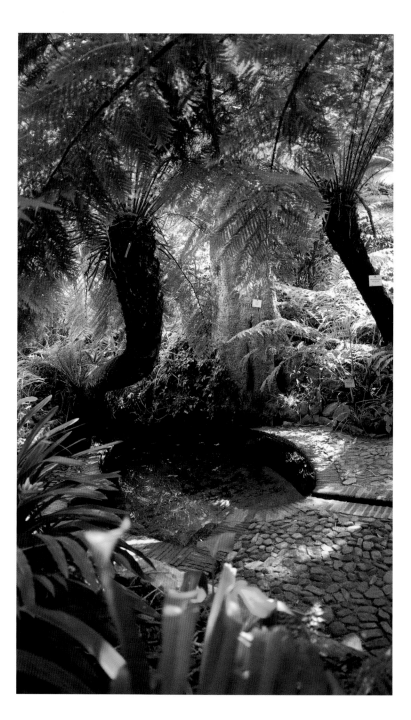

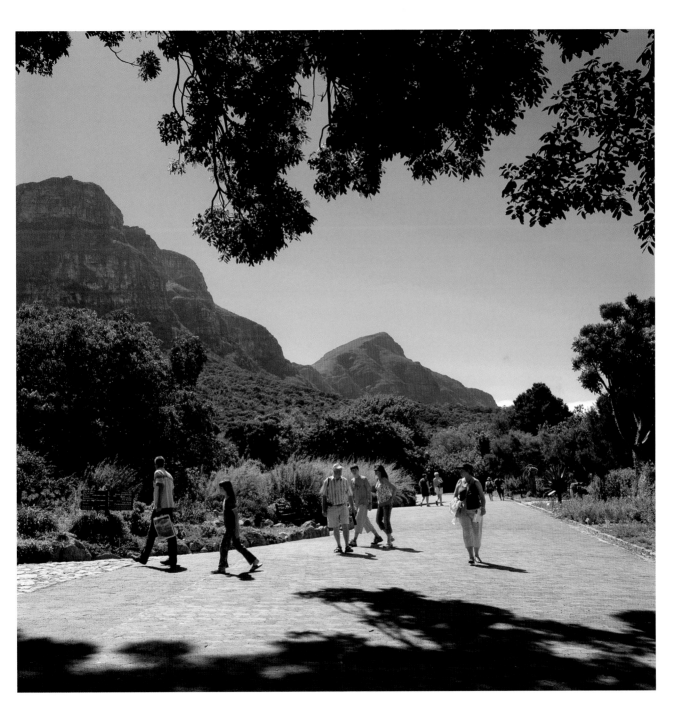

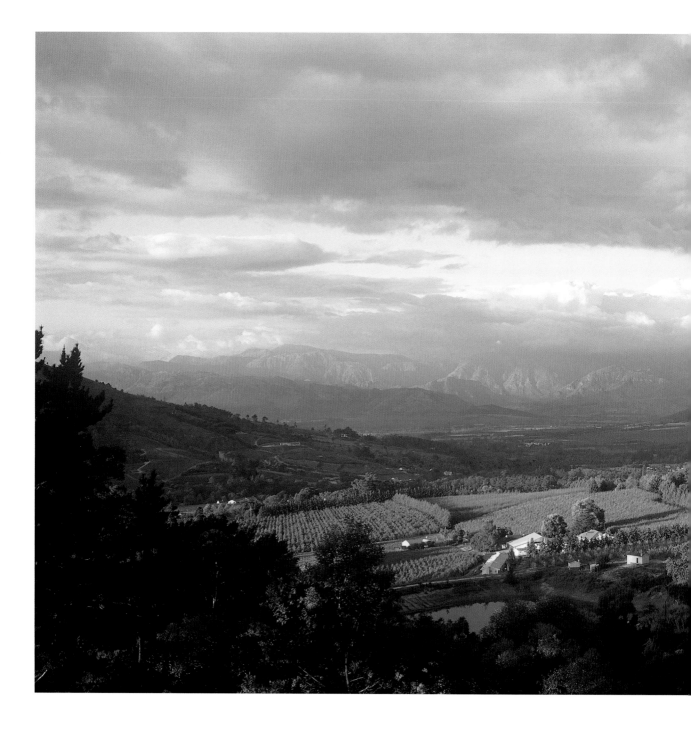

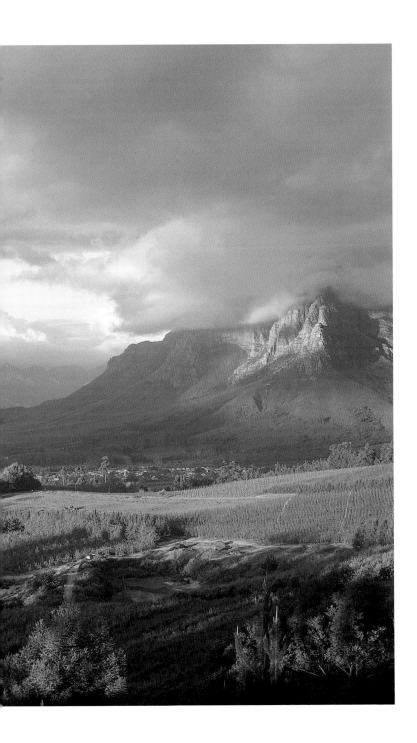

LEFT: Sunset in the Franschhoek valley as seen from the top of Helshoogte Pass, with Bothma's Kop rising on the right. Franschhoek was founded by French Huguenots who first settled here in 1688.

PAGE 30: Attractions along Stellenbosch's Dorp Street vary from museums to old pubs, homely restaurants and antique shops.

PAGE 31: Besides being part of the Winelands, Jonkershoek also offers beautiful drives and hikes.

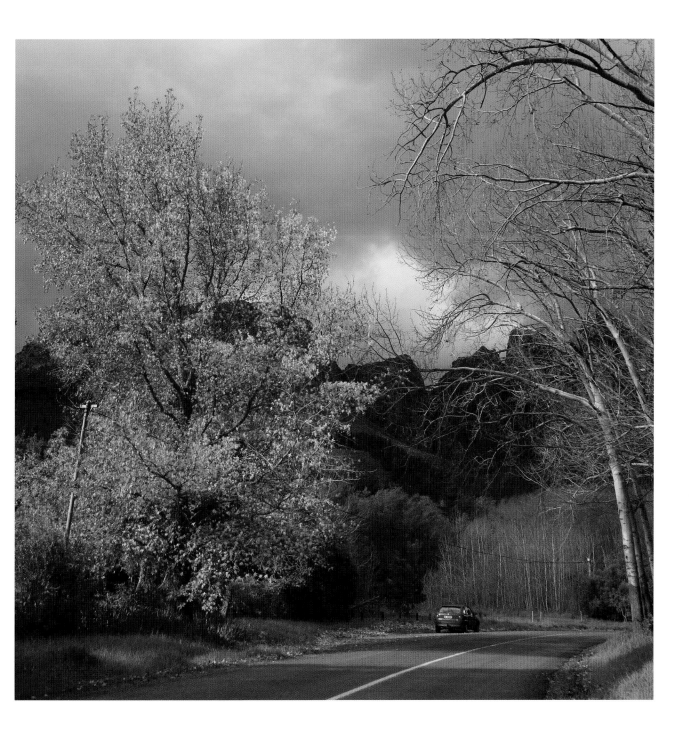

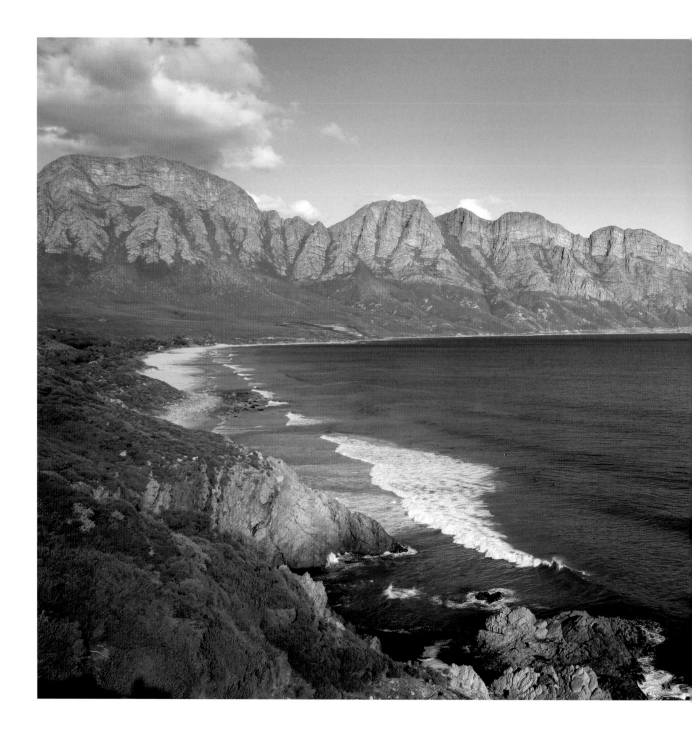

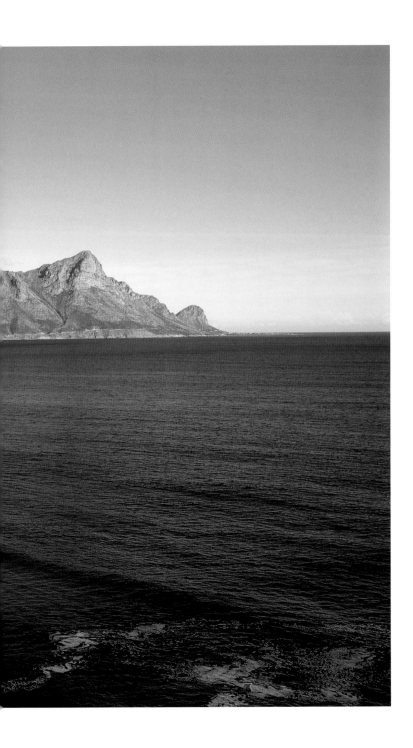

LEFT: A lookout point from Clarence Drive, one of the Cape's most scenic coastal drives, over Koeëlbaai (also known as Kogel Bay), which is a favourite surfing spot. The Kogelberg mountains in the background are part of the Kogelberg Biosphere Reserve, which was formed to protect the area's exceptional floral diversity.

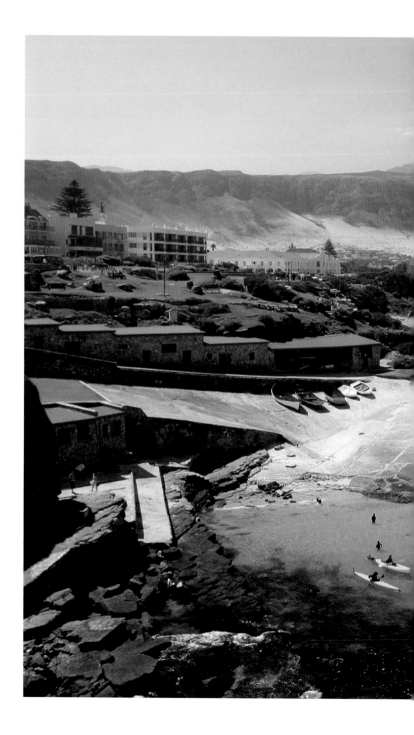

RIGHT: The old harbour at Hermanus.

PAGE 36: Houseboats moored at Kraalbaai in the Langebaan lagoon, which falls within the West Coast National Park.

PAGE 37: Cape gannets breed in large numbers at Lambert's Bay, where an excellent bird hide allows close access to the birds.

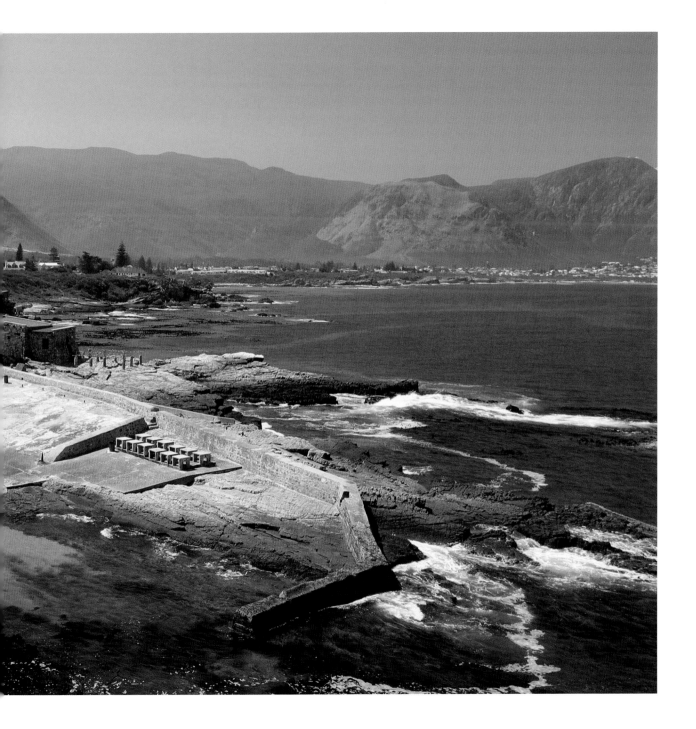

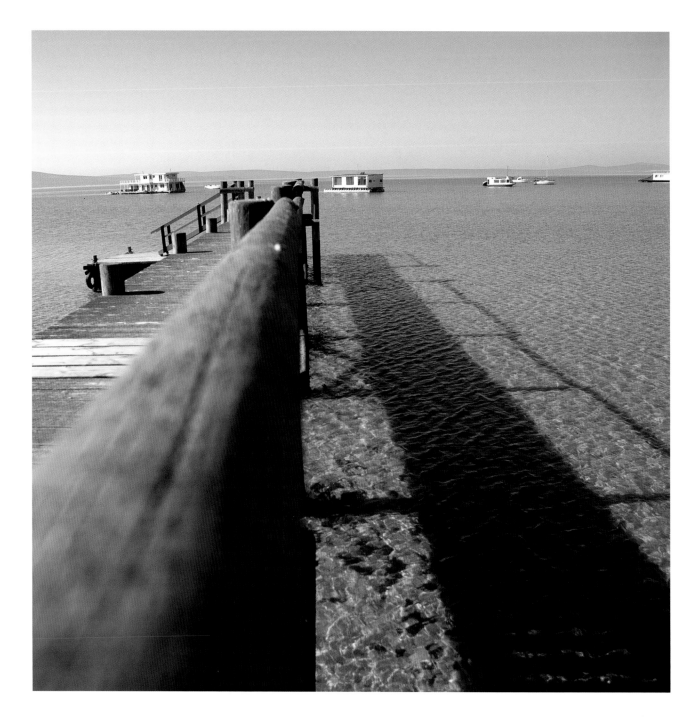

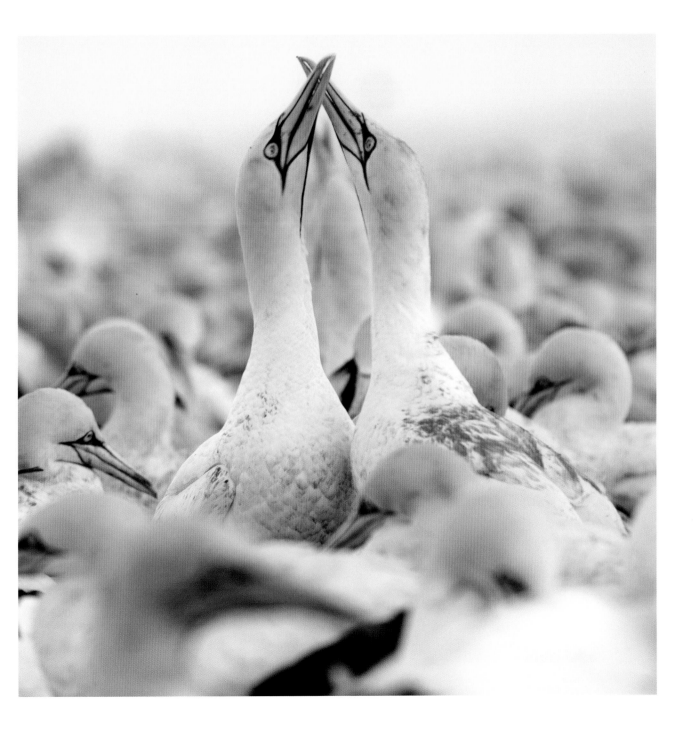

RIGHT: The Cederberg is a rugged stretch of wilderness where a donkey cart or a 4X4 are well suited to the terrain.

FAR RIGHT: The Maltese Cross is one of the Cederberg's best-known landmarks. To its left in the background lies the partially visible Sneeuberg (2 026 m), the highest peak in the range.

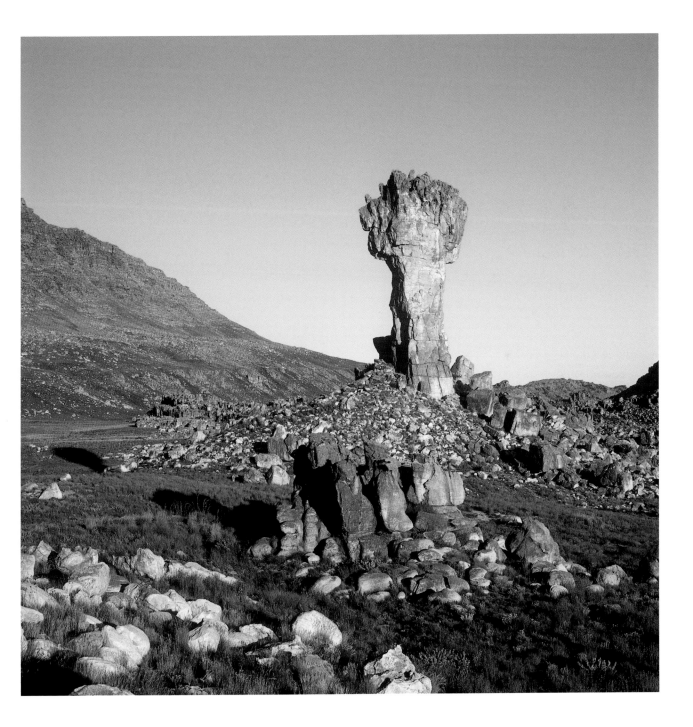

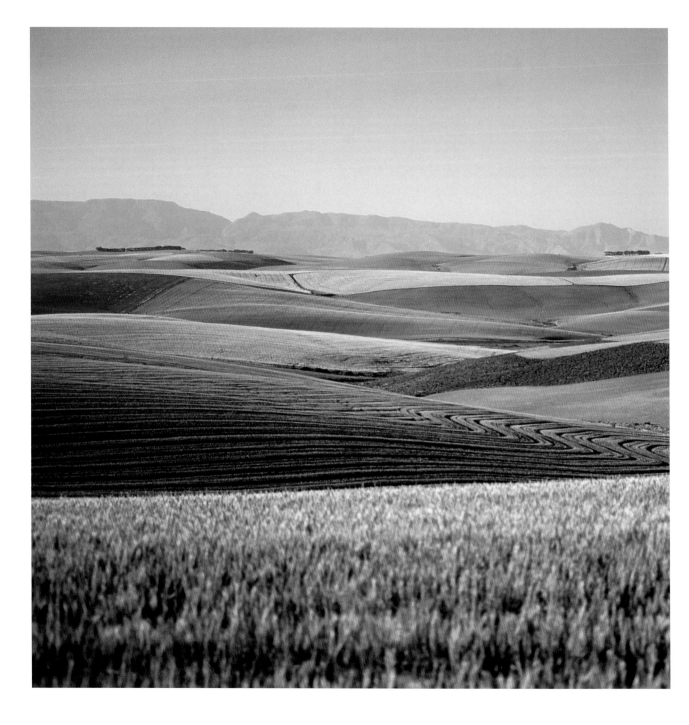

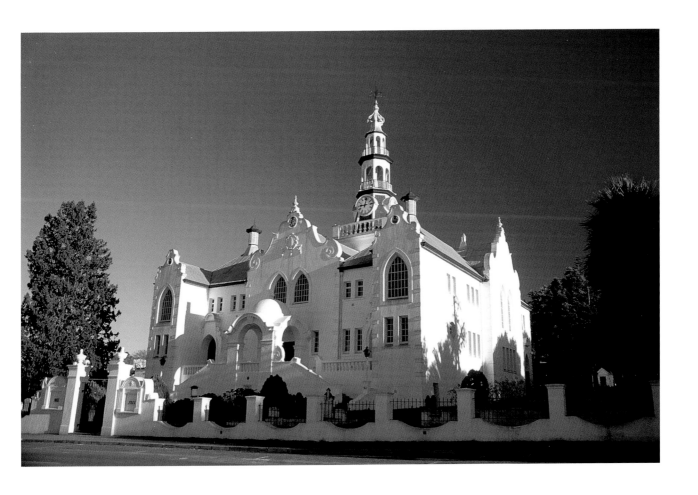

ABOVE: The Dutch Reformed Church in Swellendam, one of the major centres in the Overberg.

LEFT: The Overberg is one of South Africa's largest grain-producing areas. The wheat is cut down as soon as it is ripe, leaving it in neat rows for the combine harvesters to collect.

41

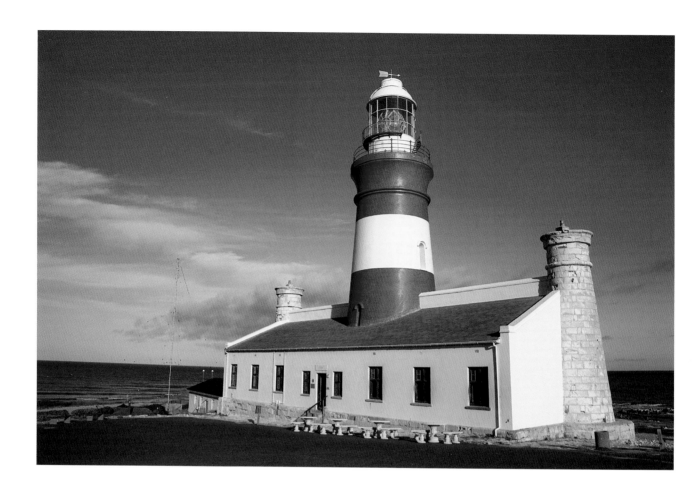

ABOVE: The lighthouse at Cape Agulhas – Africa's southernmost point – has been in operation since 1849.

RIGHT: The Waenhuiskrans (literally: 'wagonhouse cliff') cave near Arniston is said to be big enough for an ox-wagon to make a U-turn.

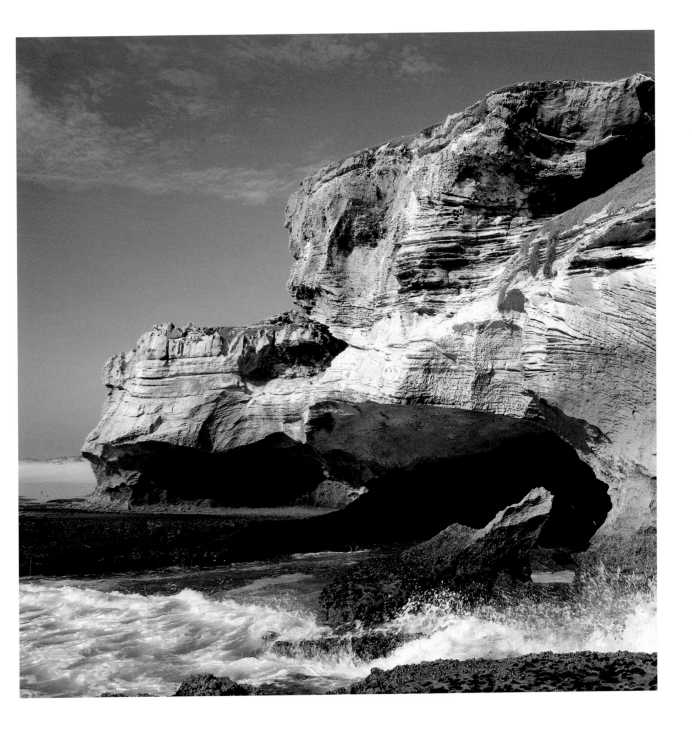

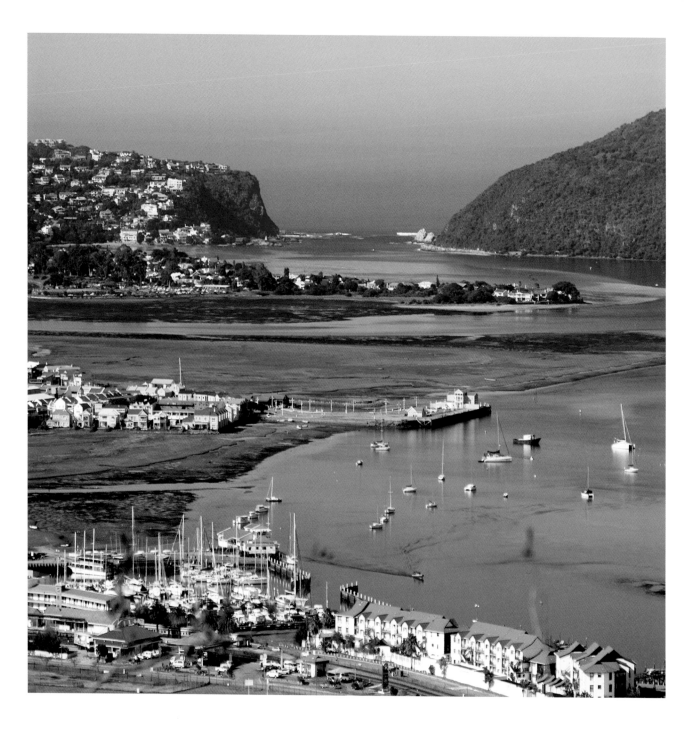

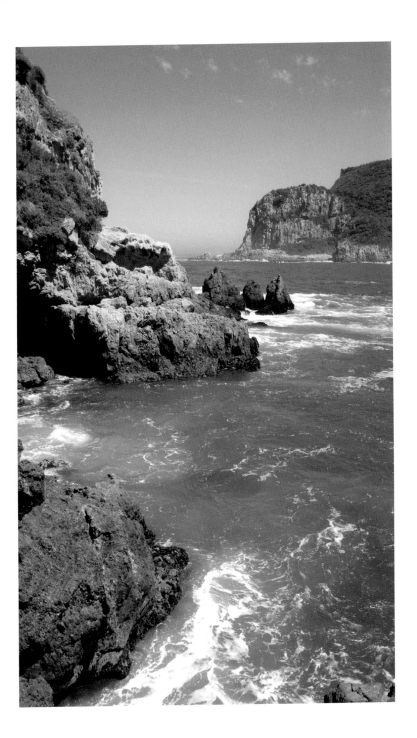

LEFT: The Knysna lagoon opens into the sea through the narrow passage between the Knysna Heads.

FAR LEFT: The town of Knysna is one of the most popular holiday destinations on the Garden Route. This view looks across the waterfront, Thesen's Island and Leisure Island towards the Heads.

THIS SPREAD: The Tsitsikamma forest is one of South Africa's last great indigenous forests. Loggers decimated the forest during the 19th century as the town of Knysna grew correspondingly as a shipping port for the timber. Giant examples of one of the most prized trees, the yellowwood (far left), still remain to be seen.

FOLLOWING SPREAD: Farm workers drive down the Oude Muragie gravel road near De Rust in the Little Karoo. The road follows the base of the Swartberg mountains westwards towards the Cango Caves and Oudtshoorn.

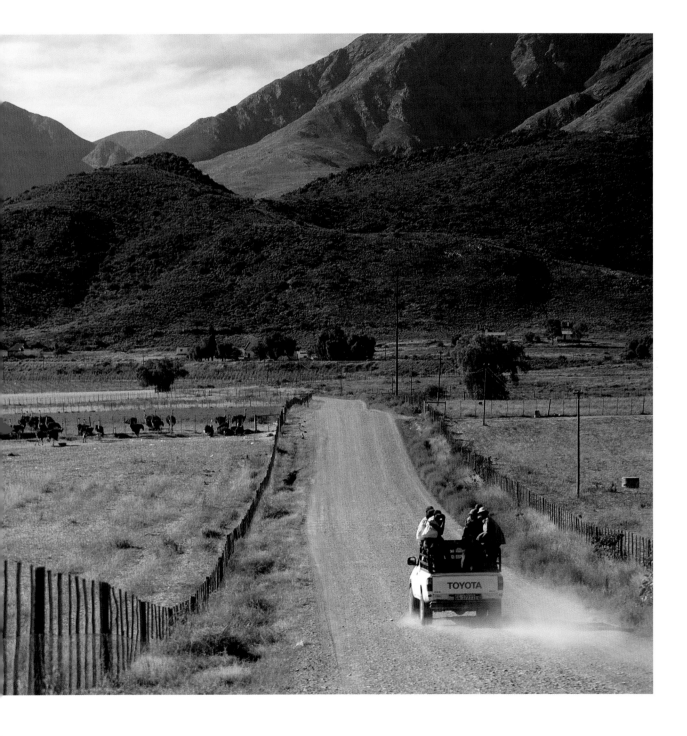

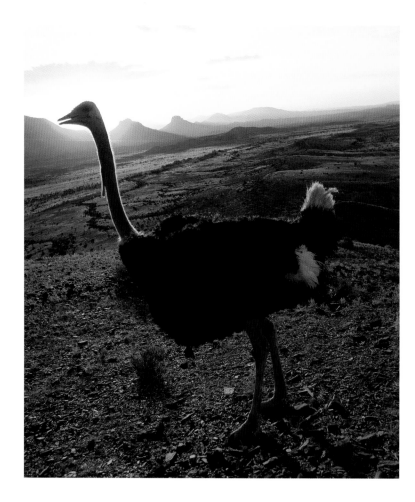

ABOVE: This windy mountain pass descends into a hidden gorge in the Swartberg range called Gamkaskloof, also known as Die Hel (The Hell) because of its inaccessibility.

RIGHT: An ostrich, with the Swartberg range in the background. Much of the Little Karoo's early agricultural boom centred around the ostrich feather trade.

FAR RIGHT: The Cango Caves outside Oudtshoorn were first explored in 1780 by a local farmer, Mr van Zyl. But the entrance to the cave was inhabited for long periods during the Middle and Later Stone Ages.

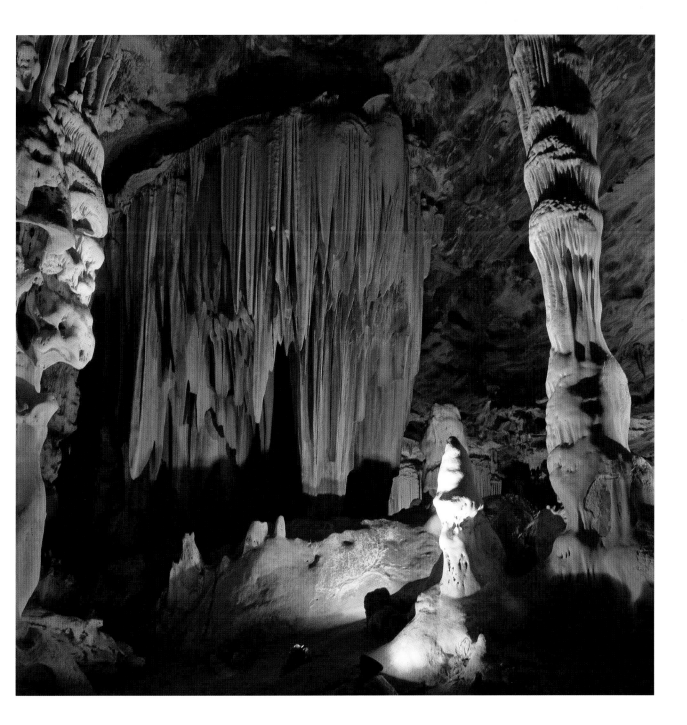

RIGHT: A typical farm scene in the Great Karoo. This arid region is suited to sheep farming and windmills like this one help to tap underground water reservoirs.

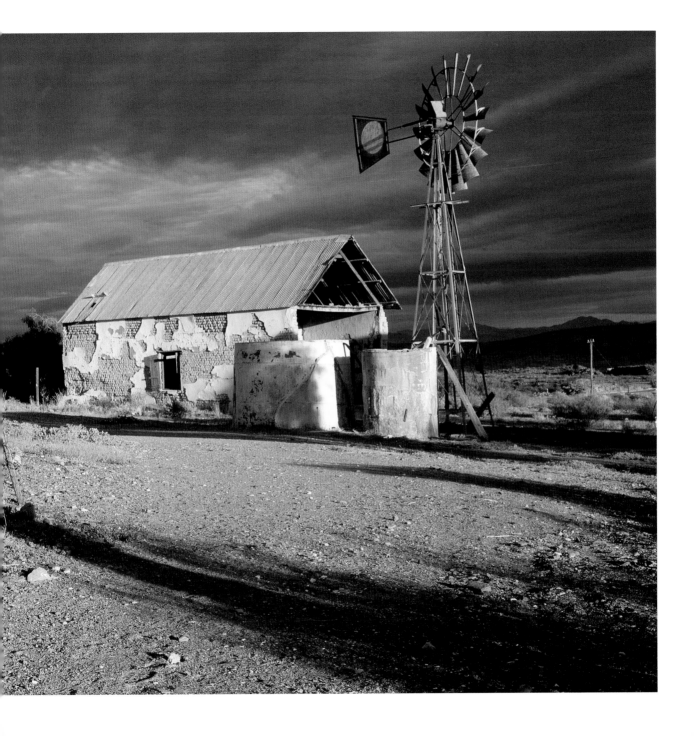

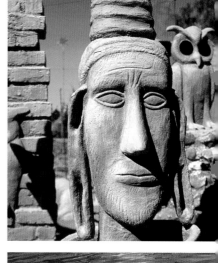
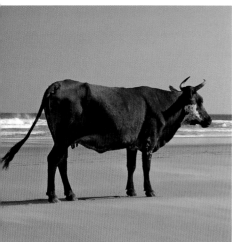
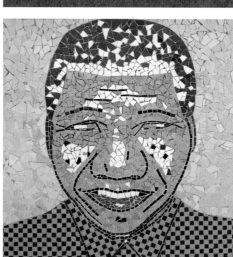
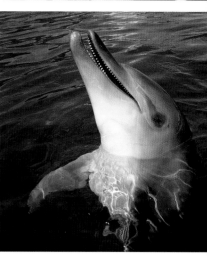
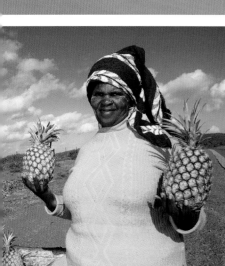
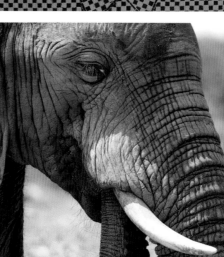

Eastern Cape

The Eastern Cape is a province full of surprises. Its main cities – Port Elizabeth and East London – lack the glamour of Cape Town, but they are the main entry points into this vast, populous province. The British colonial influence is obvious, with Anglophone town names all over the province from when the first wave of British settlers arrived here in 1820.

But the Eastern Cape is also the stronghold of the Xhosa people, with the provincial capital Mthatha being the centre of the area otherwise characterised by rural villages scattered over hills and valleys all the way down to the coast, known as the Wild Coast.

The Wild Coast is one of the Eastern Cape's biggest drawcards, offering hiking trails, camping, backpacking, surfing, horse-riding and more. Stunning beaches and resort towns adorn the entire coastline of the Eastern Cape, with Jeffrey's Bay legendary among surfers the world over. Besides Port Elizabeth and East London, both of which are also blessed with good bathing beaches, towns like Kenton-on-Sea, Port Alfred, Kidd's Beach, Cintsa, Coffee Bay and Port St Johns are also popular holiday destinations.

But it's the interior of the province that springs the real surprises. While the Transkei and other wetter parts of the province can be lush and green, the interior gradually eases out – over a series of mountain ranges – to become drier, hardier Karoo.

Towns like Cradock, Graaff-Reinet and Middelburg are old-fashioned in layout, with wide streets dating back to a time when they were made for ox-wagons. This is farming country, with Merino sheep, Angora goats and a variety of cattle breeds being farmed.

OPPOSITE FROM LEFT TO RIGHT:

- The Port Elizabeth Public Library.
- A roadside take-away stall near Mtatha.
- Cement statues at the Owl House in Nieu-Bethesda were the creative vision of reclusive artist Helen Martins.
- Cattle are often seen on the beaches of the Wild Coast.
- A mosaic of Nelson Mandela at the Nelson Mandela National Museum at Qunu where he spent much of his childhood.
- A dolphin at Port Elizabeth's oceanarium, Bayworld.
- A pineapple seller next to the N2 between Grahamstown and Peddie.
- The Addo Elephant National Park was proclaimed in 1931. Today the park is home to more than 450 elephants.
- The flightless dung beetle is found in the Addo Elephant National Park.

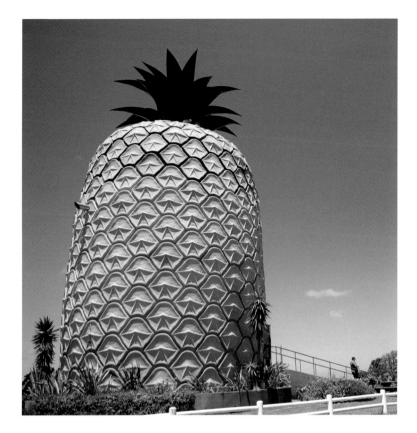

RIGHT: At the Big Pineapple just outside Bathurst you can learn all about pineapple farming and sample a variety of pineapple products.

FAR RIGHT: Sunbathers congregate where the Kariega River flows into the Indian Ocean at Kenton-on-Sea.

In the northeastern corner of the province, the Drakensberg mountains rise up, with high-lying towns such as Rhodes and Barkly East being no strangers to heavy winter snowfalls. The area is especially picturesque in autumn, when willows and poplars lining clear streams and country roads light up in yellow as their leaves change colour.

The Mountain Zebra and Addo National Parks have been luring visitors for decades, but it's the numerous new private reserves and rugged, lonely country like the Baviaanskloof valley that have been making new converts to this often overlooked province.

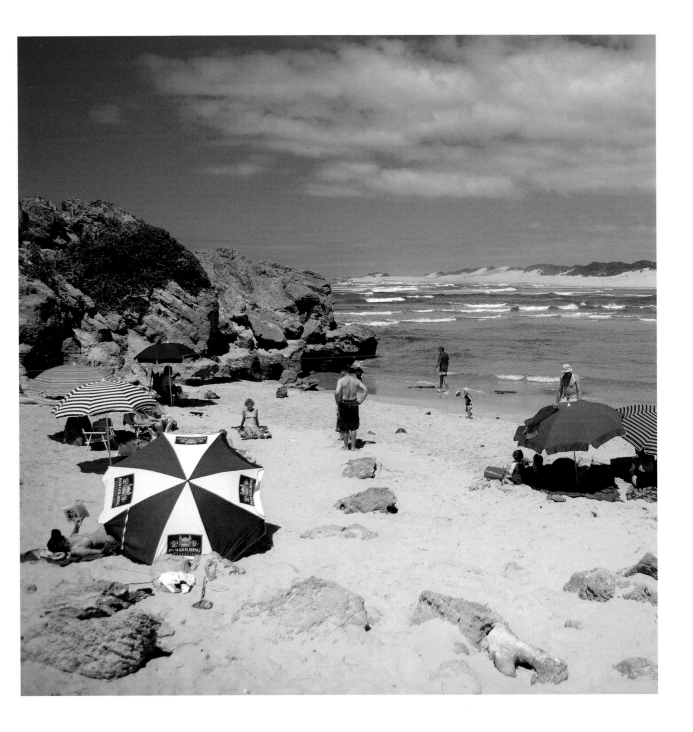

ABOVE: Several aloe species, such as this *Aloe ferox*, grow in the Eastern Cape.

RIGHT: The Mountain Zebra National Park was proclaimed in 1937 to save the Cape mountain zebra from extinction.

FAR RIGHT: The Addo Elephant National Park conserves five of South Africa's seven biomes and stretches from the Indian Ocean coastline up to the Zuurberg range.

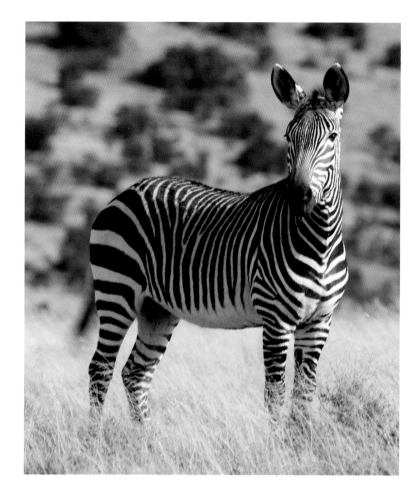

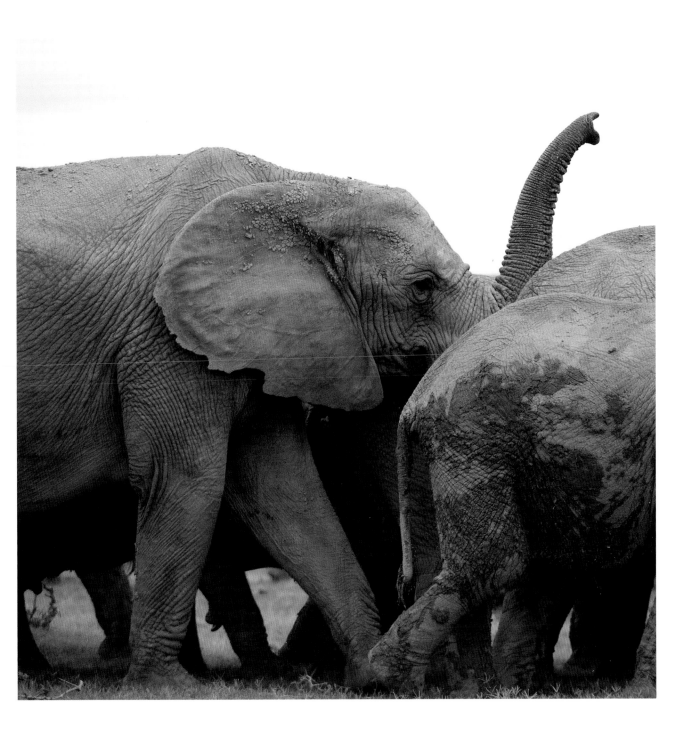

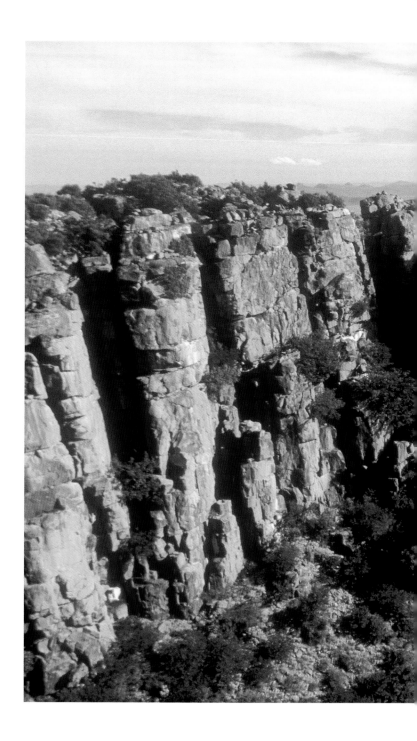

RIGHT: Dolerite pillars in the Valley of Desolation stand guard over the Camdeboo National Park outside Graaff-Reinet.

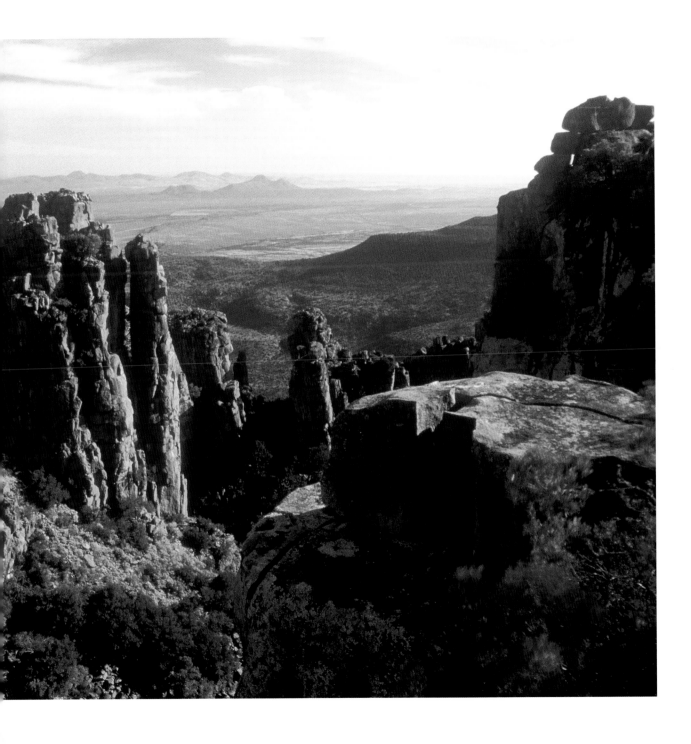

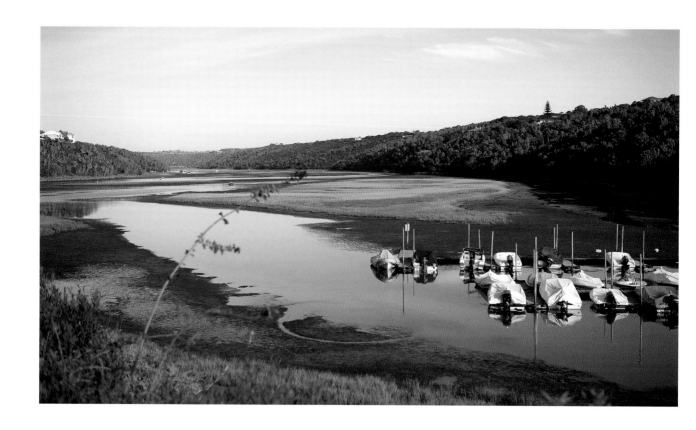

ABOVE: The Kariega River at Kenton-on-Sea.

RIGHT: The Kowie River makes a spectacular U-bend as it winds its way through the Waters Meeting Nature Reserve outside Bathurst.

FOLLOWING SPREAD: Nahoon Beach south of East London has one of the country's finest surfing breaks. It is also home to the East London Surf Lifesaving Club.

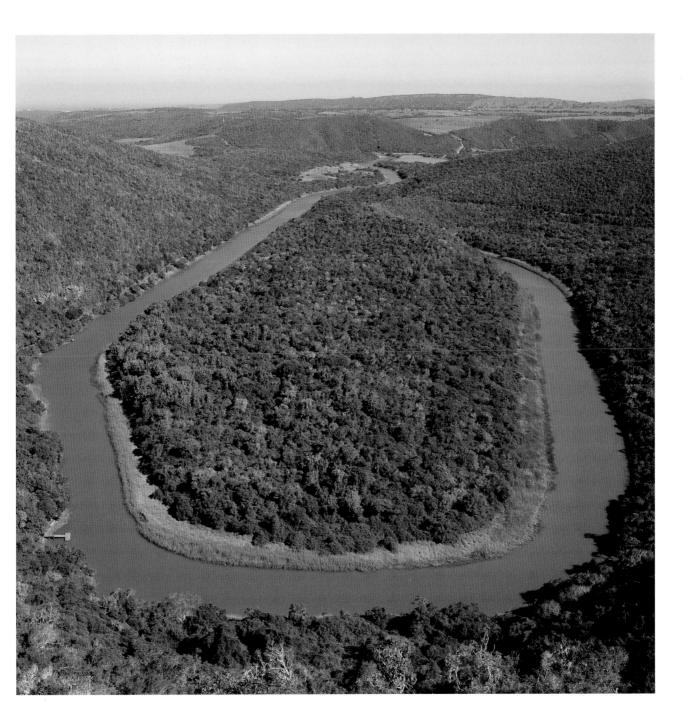

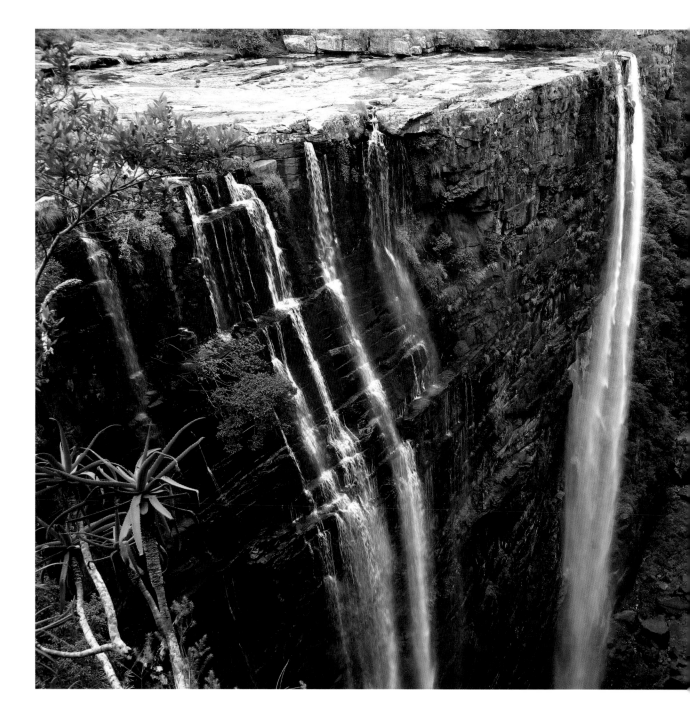

LEFT: Magwa Falls near Lusikisiki drops 146 m down to the gorge below.

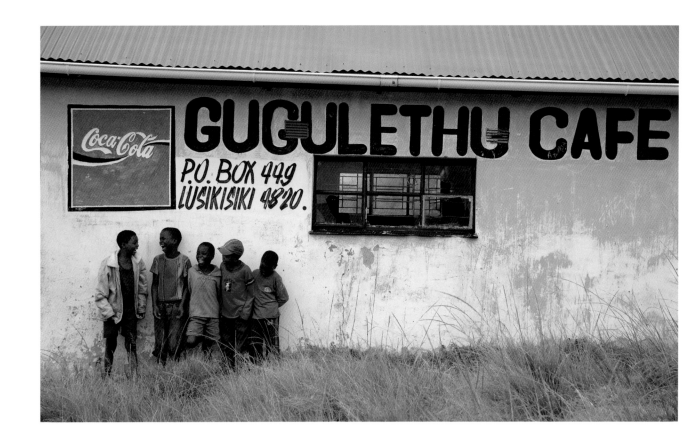

ABOVE: The rural part of the Eastern Cape is still frequently referred to as the Transkei, a name it was given as a 'homeland' during apartheid years.

RIGHT: It is commonplace to see cattle like these Ngunis on the beach of the Wild Coast near Mbotyi.

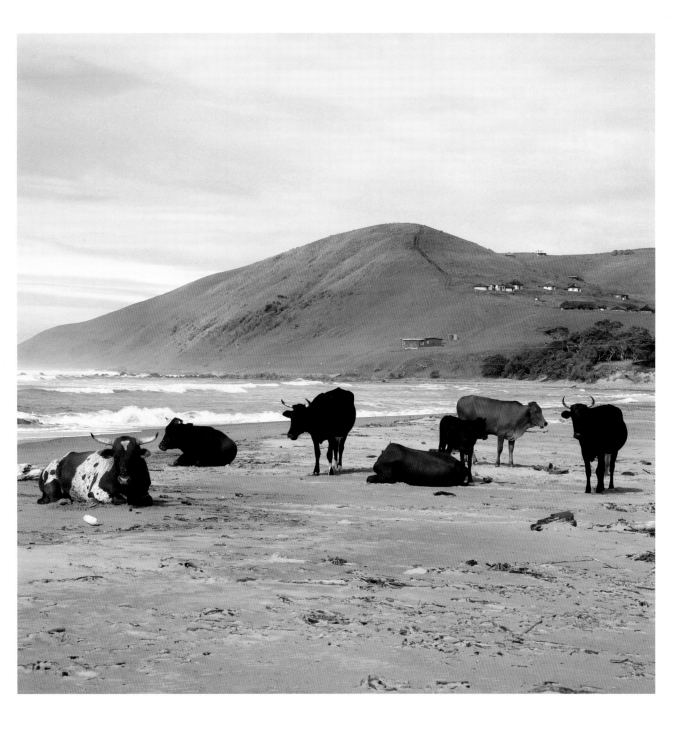

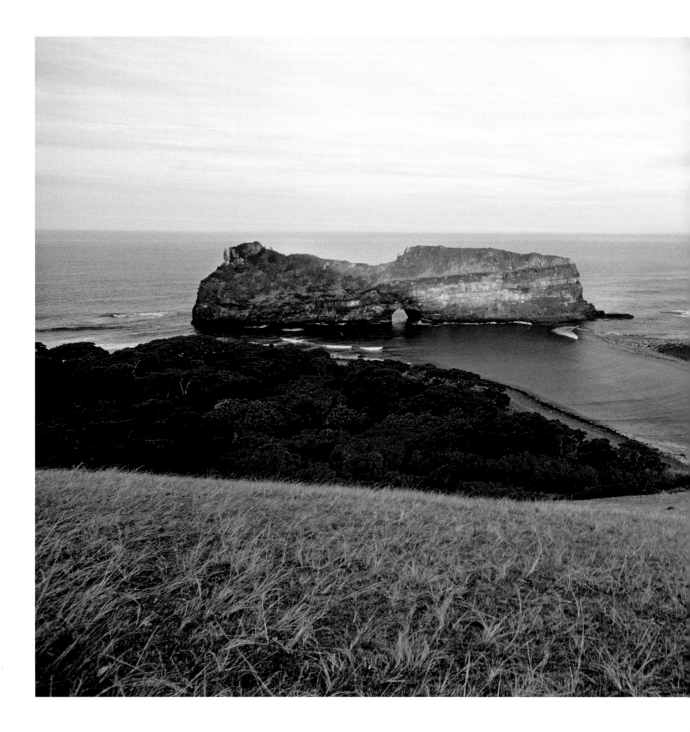

LEFT: Thousands of years of wave erosion have created the Hole in the Wall south of Coffee Bay on the Wild Coast.

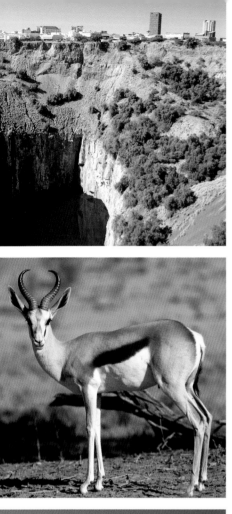

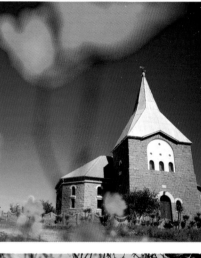
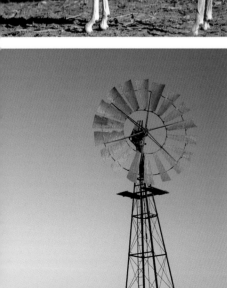
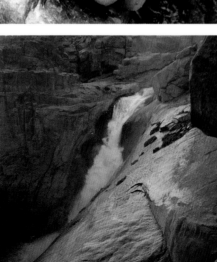

Northern Cape

This arid region is South Africa's largest province, but with just over a million inhabitants it is also the most sparsely populated. This means one thing: when visiting the area, there is plenty of room.

At the heart of the province lies the Great Karoo. Millions of years ago it was a large inland lake, populated by marsh-dwelling dinosaurs. Today it's dry as a bone for most of the year, with vast expanses stretching out over places with colourful names like Verneuk Pan ('Cheating Pan') – site of an early land speed record, Pofadder ('puff adder') and Putsonderwater ('Well-without-water').

The Kgalagadi Transfrontier National Park spills over into neighbouring Botswana, but both the South African and Botswanan sections of the park can be accessed from the Northern Cape. Famous for its red dunes, large lion population and the characteristic gemsbok (oryx), the Kgalagadi is one of the wildest places in the country, yet it is easily accessible in most places by ordinary vehicles. Giant camel thorn trees guard the ancient, dry river beds of the Auob and the Nossob rivers, while raptors such as martial eagles patrol the skies. Hot by day, the nights can be cold, when barking geckos are often the chorus that accompanies the first hour after sunset.

The Augrabies Falls are in the Orange River, South Africa's longest river, which has its source in Lesotho. Almost 2 200 km in length, the river is the main water source for irrigated agriculture in the province. Its wine and table grape industry is centred downstream from the large town of Upington towards Kanoneiland and Keimoes.

ABOVE: Verneukpan ('Cheating Pan') fills with water only in rare times of heavy rainfall.

RIGHT: An antique shop in Kenhardt.

FAR RIGHT: Donkey carts – like this one in Andriesvale – are still in everyday use all over South Africa, but especially in the Northern Cape.

PAGE 76: The isolated area around Rietfontein is known for its pans, of which Hakskeenpan ('Heel Pan') is one of the biggest.

PAGE 77: Quiver trees can be seen in high concentrations near towns such as Kenhardt. San hunter-gatherers used to hollow out the trunks of the plant to use them as quivers for their arrows.

Following the course of the Orange River, closer towards the Atlantic Ocean, lies the mountainous Richtersveld area. Also a transfrontier park (it stretches across the border into Namibia), the Richtersveld represents some of the most remarkable landscapes in the country. The exposed rock formations seem to be lifeless in the heat of the day, but small succulents thrive, with bigger species such as quiver trees and *halfmens* (literally 'half human' after its human-like silhouette) also common.

The wildflower spectacle that erupts in the Namaqualand region is also a big attraction, with especially the yellow, white and orange Namaqualand daisies often covering open areas like giant carpets.

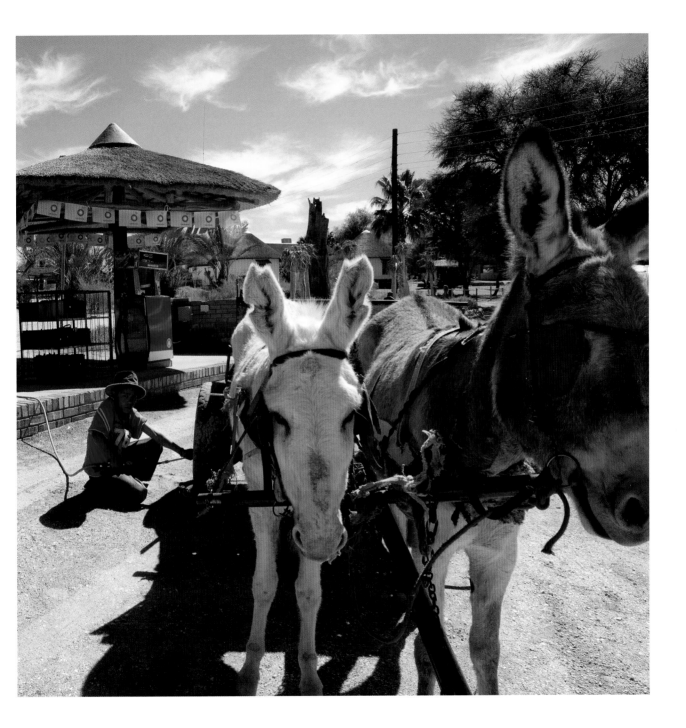

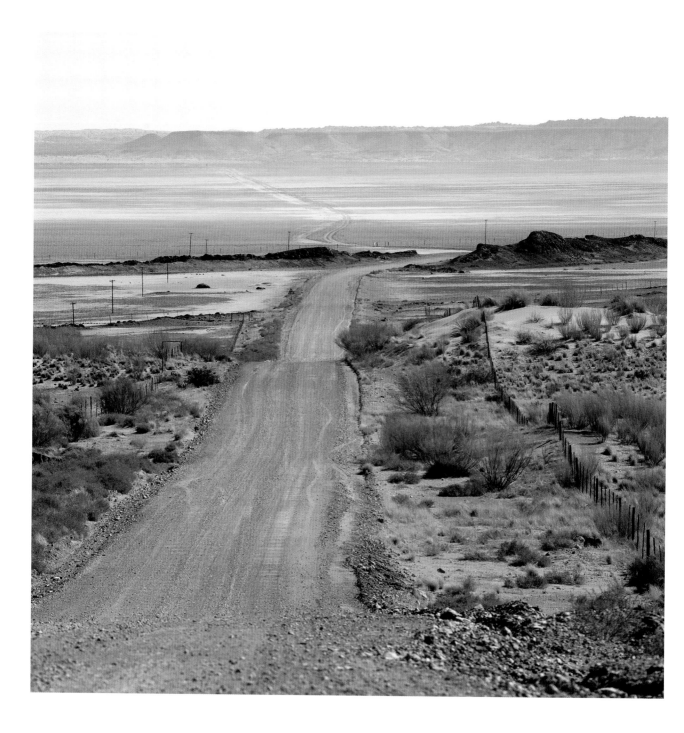

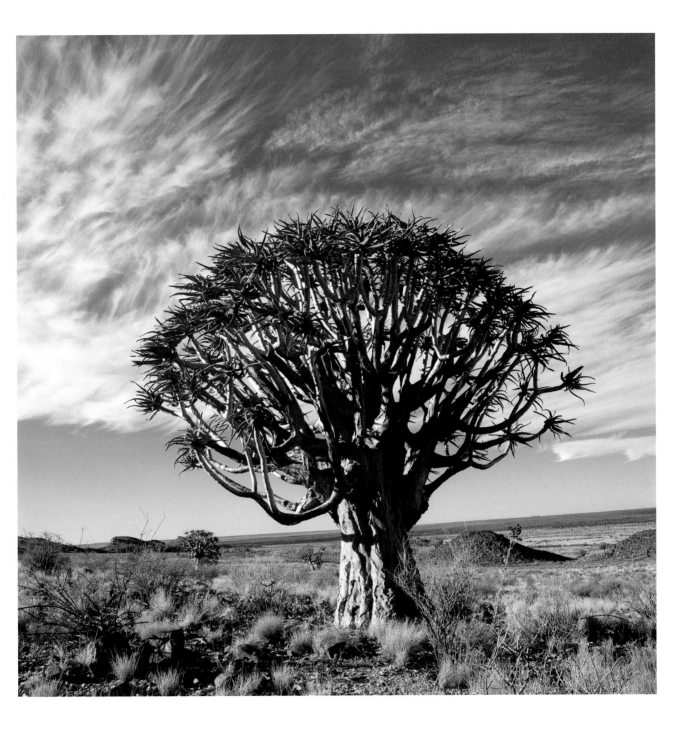

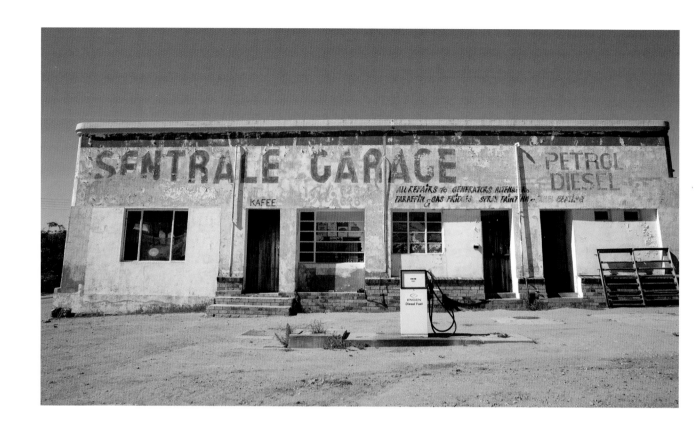

ABOVE: A garage in Kamieskroon – the area is usually visited by tourists during August and September when the wildflowers bloom in great profusion.

RIGHT: The Orange River at the Onseepkans border post between South Africa and Namibia.

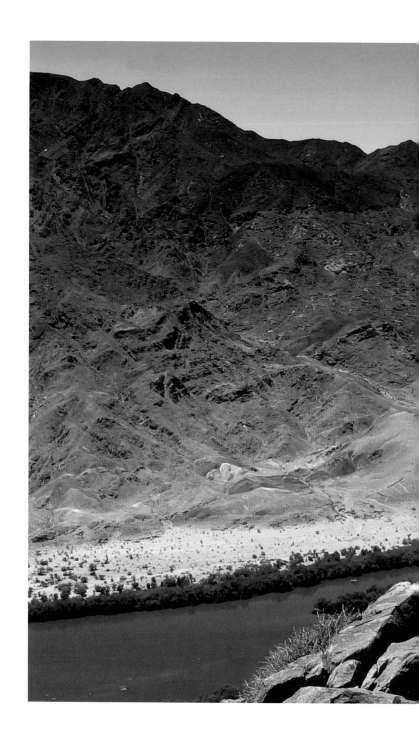

RIGHT: The banks of the Orange River give the only hint of green in the arid, mountainous Richtersveld National Park.

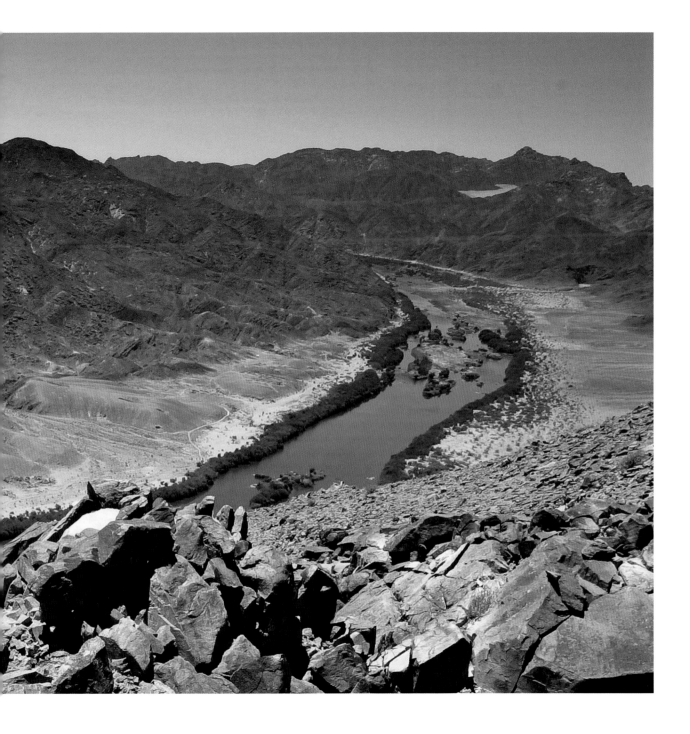

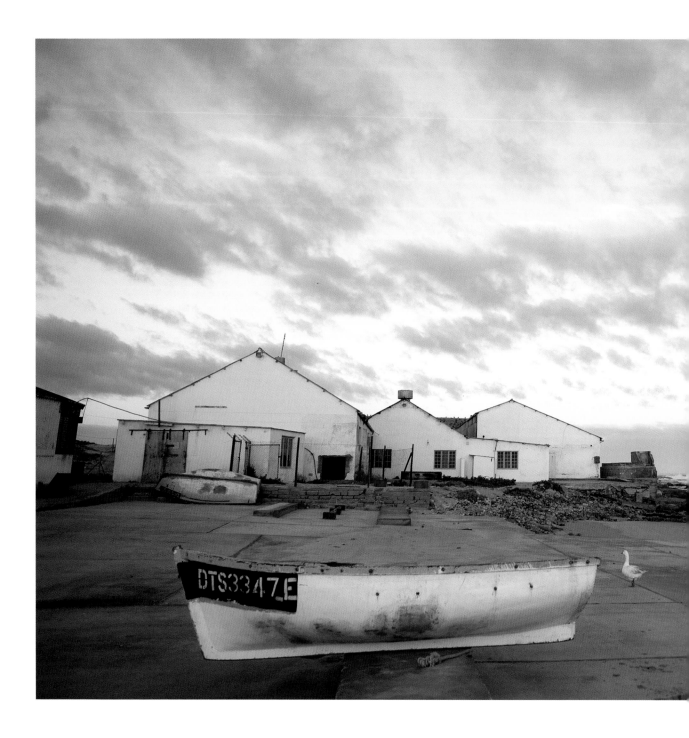

LEFT: Hondeklipbaai ('Dog Stone Bay') was first established in 1846 as a copper freight harbour, but today it mostly serves subsistence fishermen.

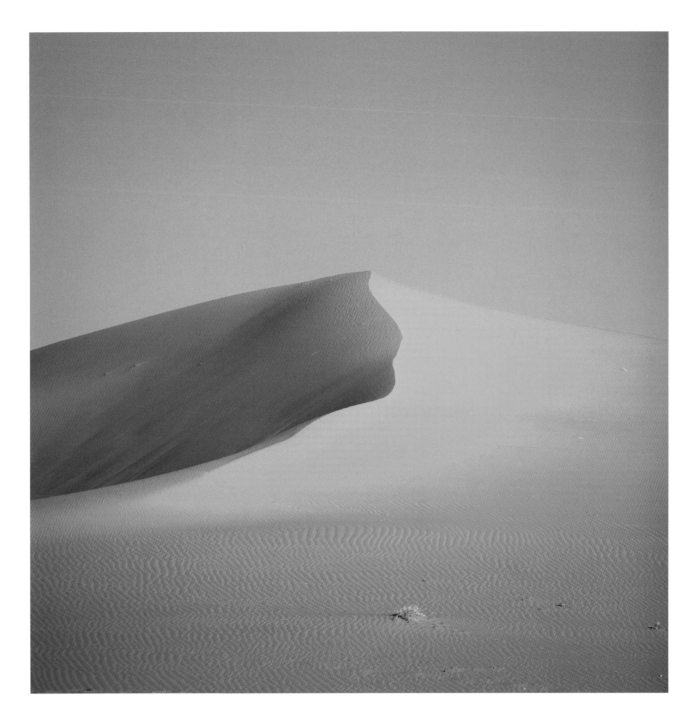

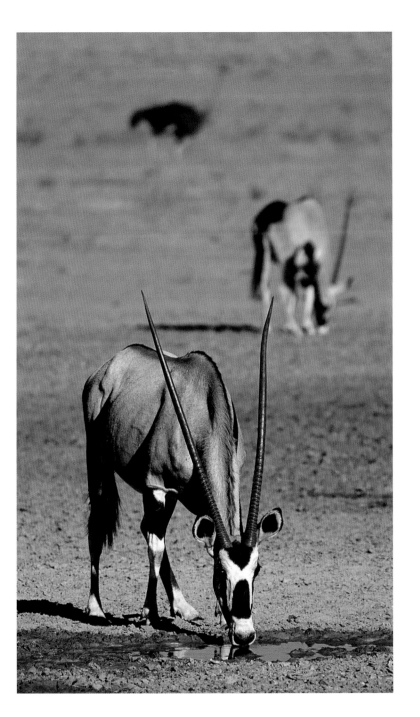

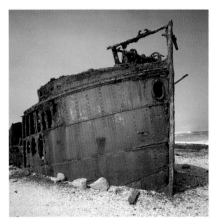

ABOVE: A wreck on the Diamond Coast between Kleinzee and Koingnaas.

LEFT: Both male and female gemsbok (oryx) carry magnificent horns.

FAR LEFT: The Kalahari Desert is about 900 000 km² in size and extends into Namibia and Botswana.

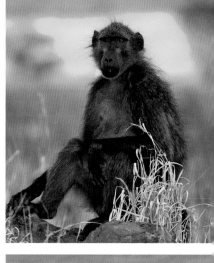

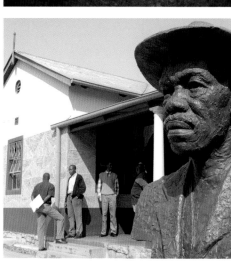
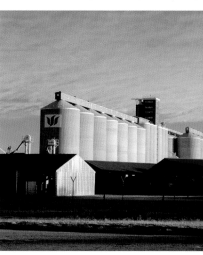
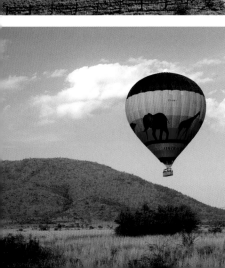

North West

Wedged into the central northern interior of the country is a largely arid province with an average annual rainfall of about 360 mm. The land varies from intensively cultivated with crops such as maize and sunflowers to the so-called 'green' Kalahari around Vryburg, where cattle herds roam, and vast swathes of bushveld where a wide variety of game can be found in private and provincial reserves.

The province is inhabited mostly by Tswana people, with the provincial capital in Mafikeng. Mafikeng – held at the time by British forces – was under siege by the Boers for 217 days during the Anglo Boer War (1899–1902). Today it is a bustling centre and a major thoroughfare to and from neighbouring Botswana.

Gold, diamond and platinum (the region's big soccer team is the Platinum Stars) mines bring in the largest chunk of the North West's income, but besides agriculture, tourism is also growing. Sun City and the adjacent, newer Lost City casino complexes have for years been synonymous with decadent luxury and endless entertainment options. An additional part of their attraction is that they are set on the edge of the Pilanesberg National Park, known for its good populations of elephants, black rhinos and lions.

Madikwe National Park – right on the Botswana border – is home to both black and white rhinos, as well as raptors such as Verreaux's eagle and the endangered Cape vulture.

Smaller provincial parks include Barberspan, an important wetland and bird sanctuary, as well as the Molopo Game Reserve in the far northwestern corner of the province where one

OPPOSITE FROM LEFT TO RIGHT:

- The Valley of the Waves at the Sun City hotel complex entertains visitors with artificial waves.
- A guttural toad seen on a nightdrive at the Madikwe Game Reserve.
- Chacma baboon, Pilanesberg Game Reserve.
- Klerksdorp is one of the province's major towns and a popular destination for gliders.
- The Mphebatho Cultural Museum in Moruleng (Saulspoort).
- Grain silos in Schweizer-Reneke.
- Hot-air balloon rides are very popular in the Pilanesberg Game Reserve as they allow one to approach game stealthily.
- Sunrise over the Hartbeespoort Dam just south of Brits.
- A typical granite outcrop in the Dikhololo game reserve north of Brits in the bushveld.

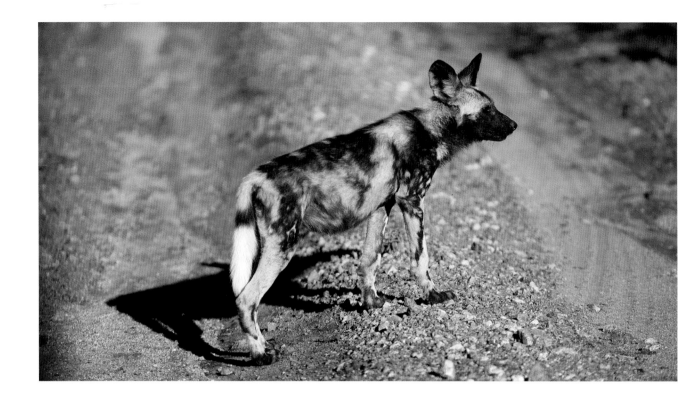

ABOVE: African wild dogs (also called painted hunting dogs) like this one in the Madikwe Game Reserve are an endangered species and difficult to see in the wild.

RIGHT: Mankwe Dam in the Pilanesberg Game Reserve has a very popular bird and game hide accessible to day visitors. The reserve is 580 km² big and contains the Big Five: lion, leopard, rhino, elephant and buffalo.

literally feels as if you're at the very outer edge of South Africa. It is wild and lonely country, beautiful in its simplicity.

The Magaliesberg mountain range, which stretches westwards from Gauteng province into the North West, is another scenic area worthy of further exploration. Dams such as the Bloemhof Dam and Hartbeespoort Dam are popular boating and angling destinations and, especially at weekends, locals from surrounding towns flock to the campsites and resorts on their banks.

South Africa's second-largest river, the Vaal, forms the southern border of the province and alluvial diamonds have been mined on its banks for over a century around towns such as Christiana and Bloemhof.

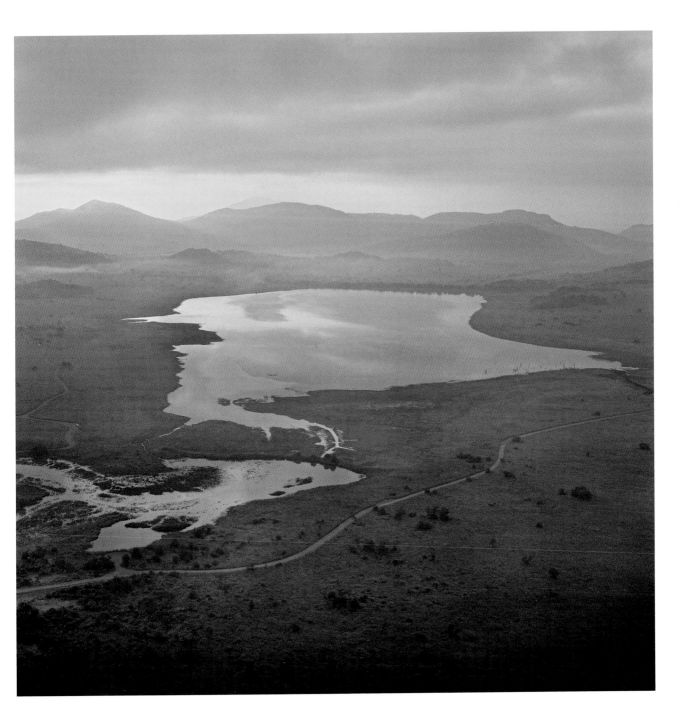

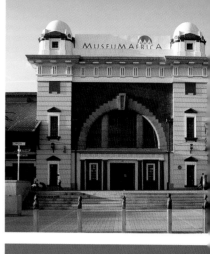
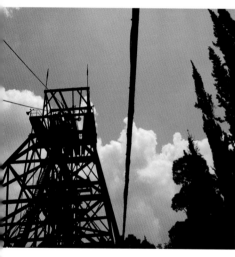
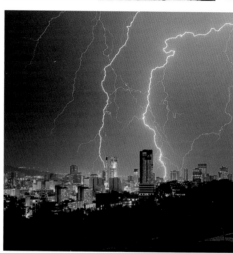
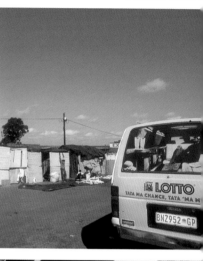

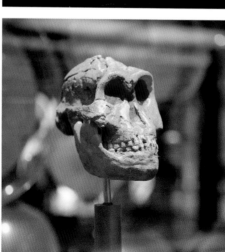

Gauteng

With over ten million inhabitants, Gauteng is South Africa's most populous province and the business powerhouse that drives the country's economy. The twin cities of Johannesburg (known for short as Joburg, or simply Jozi) and Pretoria (the municipality is known as Tshwane) have grown so much in the last few decades that they have virtually become one, their outer suburbs meeting at Midrand, traditionally the middle point between the two.

Johannesburg was founded on the discovery of gold on the famous Witwatersrand basin in 1886, and the city's gold mines have produced a massive 41 000 tonnes of gold since then. South Africa was only recently overtaken (by China) as the biggest producer of gold in the world. The word Gauteng literally means 'place of gold' in Sesotho.

As a result of the employment opportunities it offers, people have come to Gauteng from all over Africa, and Johannesburg is easily South Africa's most cosmopolitan city. Parts of its inner city have been rejuvenated, with Newtown's Nelson Mandela Bridge having become as much part of the skyline as the thick cigarette stub of Ponte Tower and the thin stem of the Hillbrow Tower.

Soweto, which lies to the southwest of Johannesburg (the name Soweto is an acronym dating from the apartheid era: Southwestern townships), is also home to two of the biggest Premier League soccer (football) teams in the country: Orlando Pirates and Kaizer Chiefs. Orlando Pirates was founded in 1937 in Orlando East, a neighbourhood of Soweto, while Kaizer Chiefs is a newer outfit, founded in 1970 by Kaizer Motaung.

OPPOSITE FROM LEFT TO RIGHT:

- Pretoria's trademark purple jacaranda blooms frame the Union Buildings, the seat of the government.
- A statue of Chief Tshwane outside the Pretoria City Hall. The municipality of Pretoria is now called Tshwane.
- Museum Africa in Newtown, Johannesburg.
- A mine shaft at Gold Reef City, a historical theme park in the south of Johannesburg.
- Gauteng province gets rain in the summer, when spectacular electric storms often light up the night skies.
- A minibus commuter taxi in Soweto, the largest township in the country.
- One of the colourful cooling towers at Orlando in Soweto.
- The Cradle of Humankind World Heritage Site is between Pretoria and Johannesburg and displays important archaeological finds from the Sterkfontein and Wonder caves.
- The Apartheid Museum, Johannesburg.

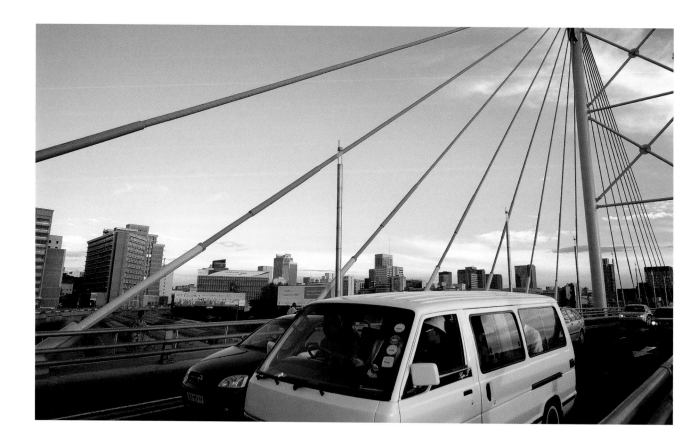

ABOVE: Nelson Mandela Bridge in Newtown.

RIGHT: Downtown Johannesburg.

PAGE 94: An aerial view of Soweto.

PAGE 95: The Telkom Joburg Tower (also known as the Hillbrow Tower) is 269 m high and was completed in 1971.

Despite the heavy urbanisation of Gauteng, it also has several small nature reserves. Rietvlei Nature Reserve and Marievale Bird Sanctuary are havens for waterbirds especially, while Suikerbosrand offers a glimpse of what the rocky granite ridges of Johannesburg looked like in the days before the mine shafts were sunk. These refuges are all barely an hour's drive from the heart of this small province.

The Cradle of Humankind World Heritage Site is near Krugersdorp and showcases some of the earliest hominid fossils ever recovered – the Sterkfontein, Kromdraai, Swartkrans and Wonder caves, the sources of these finds, lie within the site.

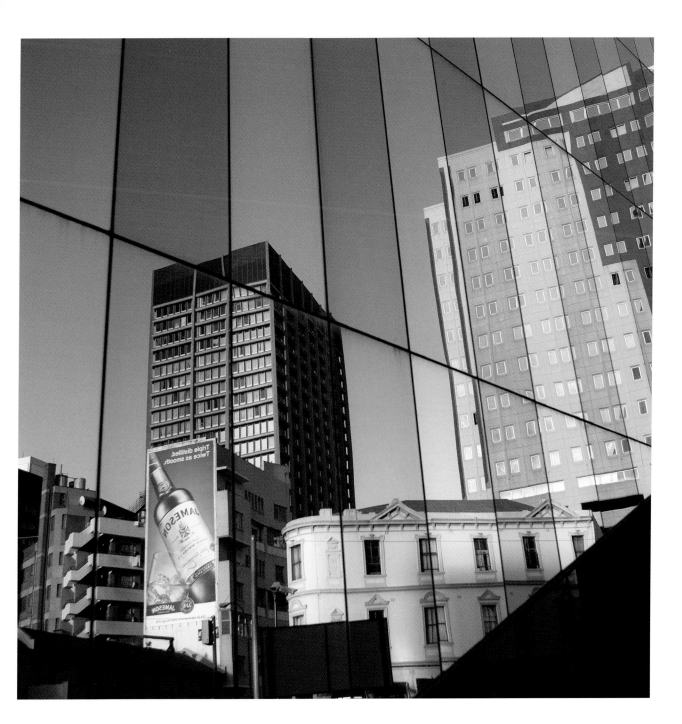

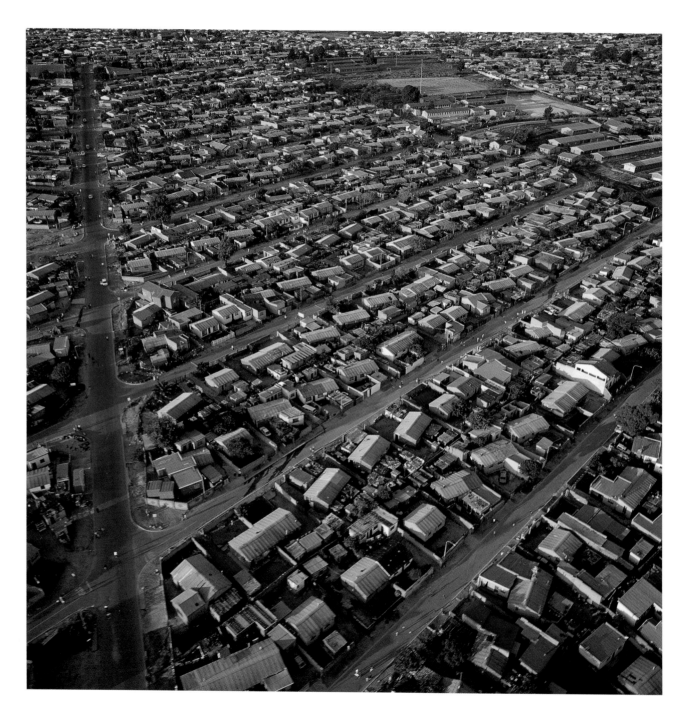

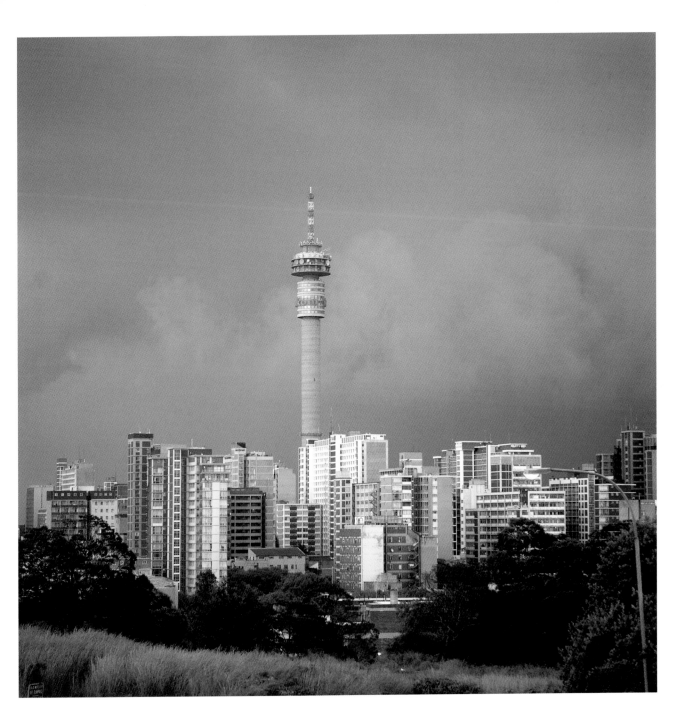

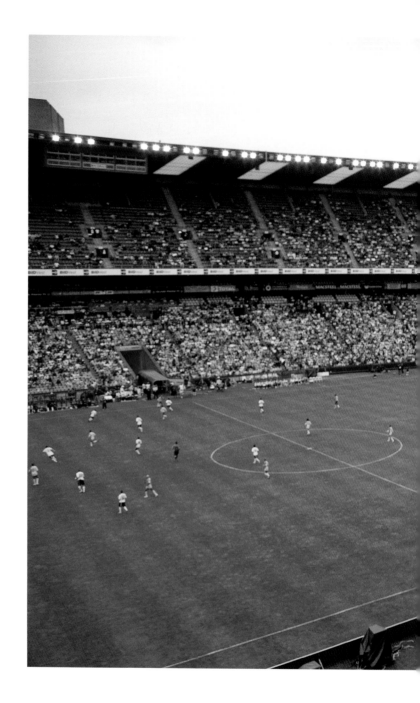

RIGHT: Ellis Park Stadium in downtown Johannesburg – the place to which soccer-mad South Africans flock for their soccer fix in Gauteng province.

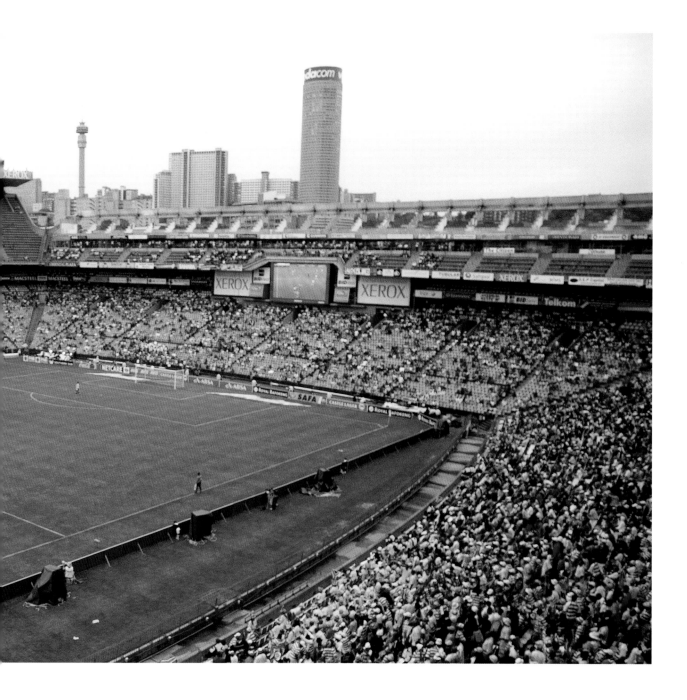

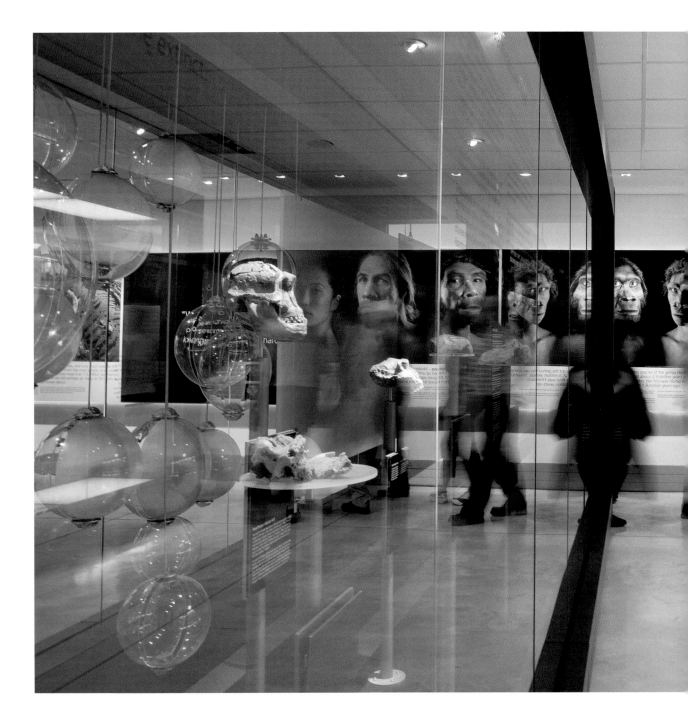

LEFT: The Cradle of Humankind World Heritage Site at Sterkfontein. The Sterkfontein caves yielded the famous homonid fossil nicknamed Mrs Ples (*Australopithecus africanus*) in 1947. It was found by Dr Robert Broom and John Robinson and is dated at 2,1 million years old.

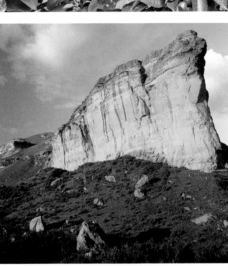
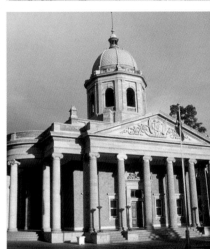
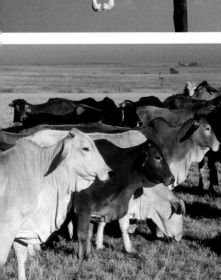

Free State

The Free State is synonymous with grasslands where cattle and sheep roam amidst termite mounds, black coots bob in reed-fronded farm dams and falcons wait patiently for prey as they watch from roadside telephone poles. Elsewhere, neat rows of sunflowers and maize add a splash of yellow and green during the height of summer, when thunderstorms provide the vital rain necessary for such large-scale cultivation of the land.

Most of the smaller towns have a thick-barrelled set of grain storage silos, the silhouettes of which can be seen on the horizon long before the rest of town becomes visible. This largely flat expanse of land is known as the Highveld, and while it stretches into some of the neighbouring provinces, the Free State lies at the heart of it.

Move towards the edges of the province though, and a different landscape appears. The border with the mountain kingdom of Lesotho is made up by the Maluti mountains and the Caledon River. The town of Ficksburg is famous as a producer of cherries and asparagus, while the Golden Gate National Park showcases the beautiful yellow-orange sandstone cliffs typical of the eastern Free State.

The Orange River forms the southern boundary of the province and there are two major dams – the Gariep and the Vanderkloof – which have nature reserves on their shores while also being popular boating and fishing destinations.

The southern Free State is a transitory zone between the Highveld and the Karoo, with rocky hillocks adorning the landscape as the vegetation becomes more arid.

OPPOSITE FROM LEFT TO RIGHT:

- Basotho ponies are still used to traverse the rugged Maluti mountains in the eastern Free State.
- Cherry farming in the Ficksburg district.
- A suricate on the lookout for predators.
- An entrance to a farm near Steynsrus.
- Golden Gate National Park is home to beautiful sandstone cliffs.
- The Raadsaal in the centre of Bloemfontein was completed in 1893 and is one of the most prominent historical sandstone buildings.
- Brahman cattle are extensively farmed in the province.
- Downtown cityscape in Bloemfontein.
- Maize fields in the Reitz district.

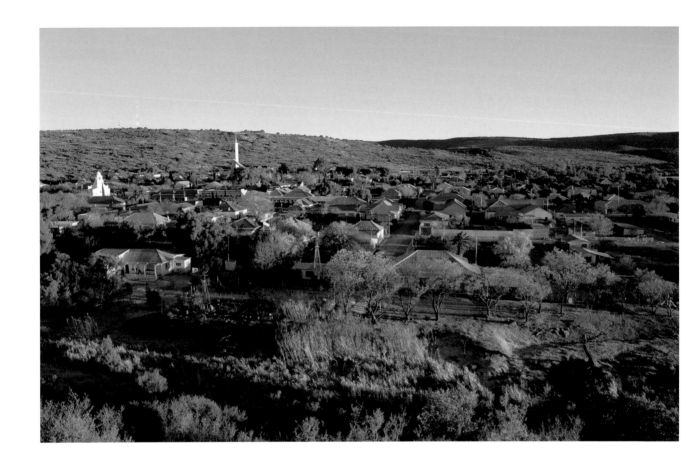

ABOVE: Fauresmith in the southern Free State was founded around the Dutch Reformed Church built to serve the district's farmers.

RIGHT: Cosmos flowers grow on disturbed ground all over the Highveld and the eastern Free State.

Almost dead centre in the province lies its capital, Bloemfontein, also the judiciary capital of South Africa. The northern Free State towns of Welkom and Odendaalsrus serve the rich gold fields that are found in the area. Nearby, between Vredefort and the Vaal River, lies the Vredefort Dome where a meteorite collided with Earth two billion years ago. It is one of the biggest such sites in the world (the meteorite itself is estimated to have been 10 km in diameter and the entire impact scar is about 380 km wide). It is a UNESCO World Heritage Site.

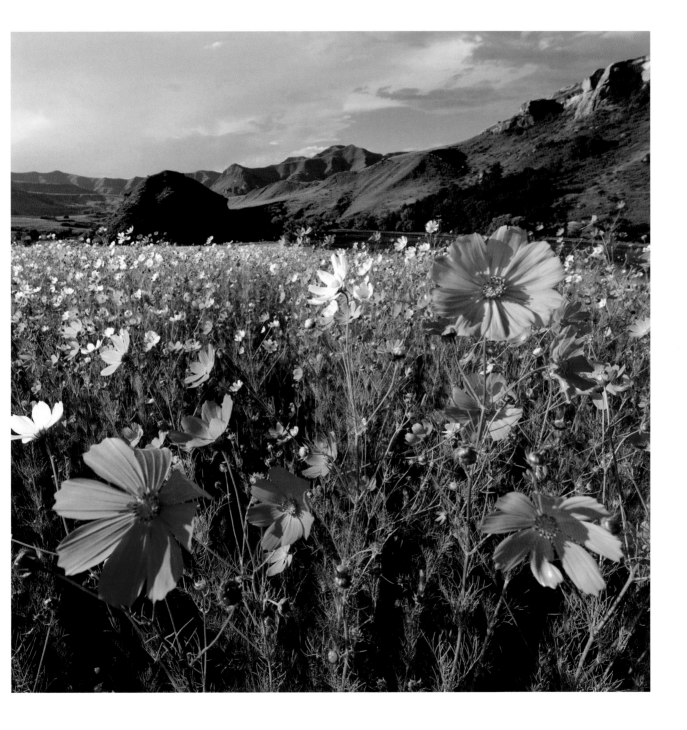

RIGHT: Sunflowers dutifully face the sun on a farm in the Heilbron district.

PAGE 106: Autumn colours in the Golden Gate National Park.

PAGE 107: A sheep farm in the southern Free State.

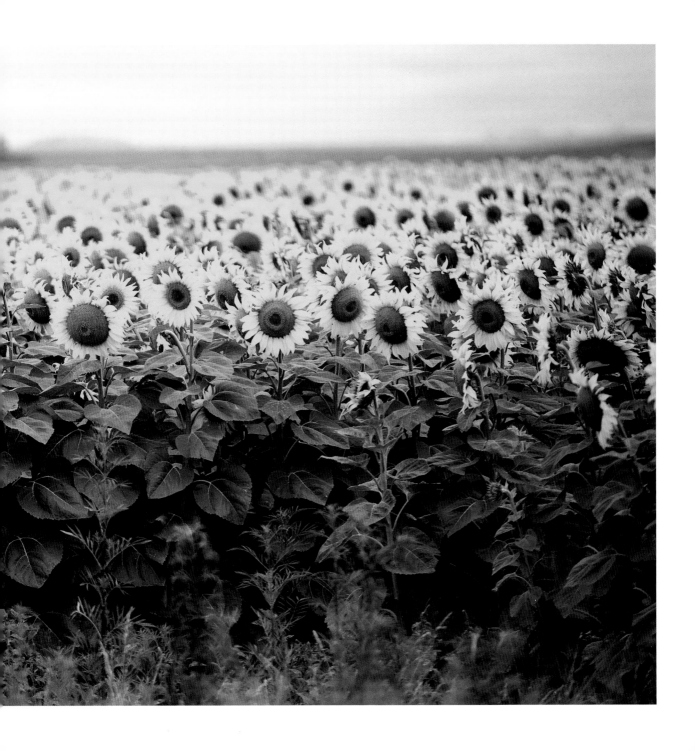

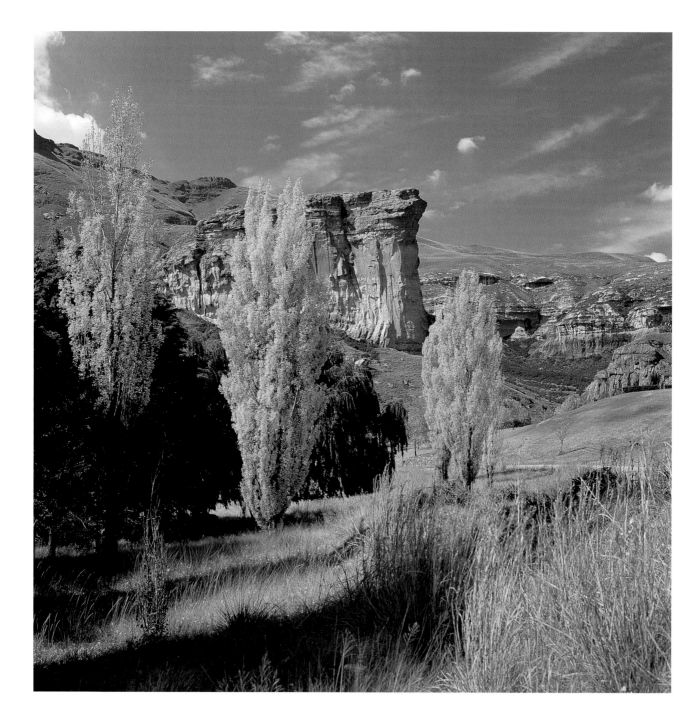

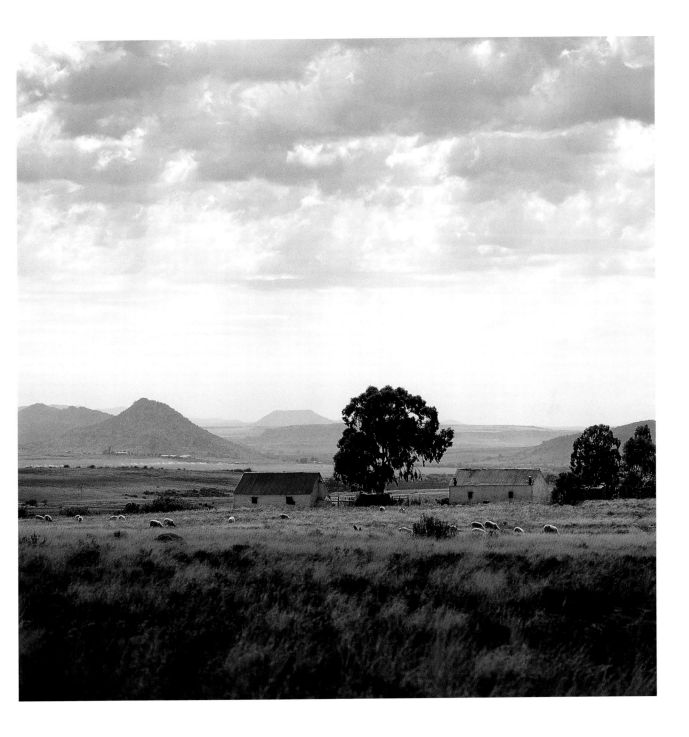

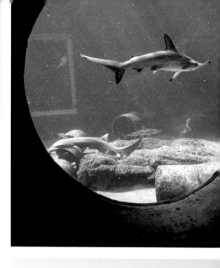
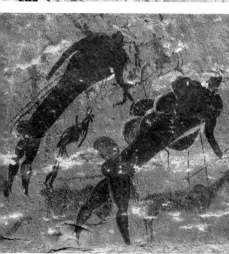
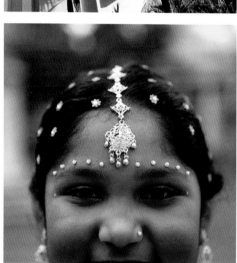
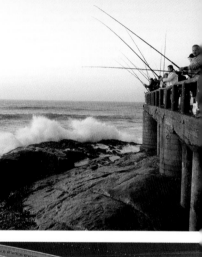
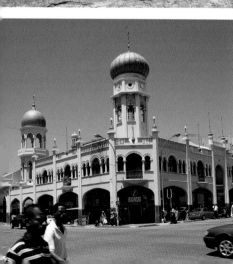
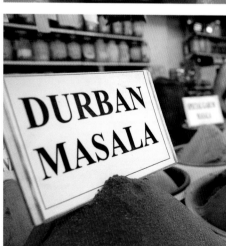

KwaZulu-Natal

From the highest peaks of the Drakensberg mountain range, down through the rolling vistas of the Valley of a Thousand Hills to the lush coastal forests of the iSimangaliso Wetland Park, KwaZulu-Natal is one of South Africa's most richly varied provinces when it comes to landscape.

As the name indicates, it's predominantly the home of the Zulu speakers, whose traditional beehive-shaped grass huts can still be seen in some areas. For the most part, though, it's a province where bustling farming activity (cattle in the Midlands, sugar cane closer to the coast) overlaps with densely populated rural areas, which in turn are bordered by world-class nature reserves.

Situated at the confluence of the White and the Black Mfolozi rivers on the royal hunting fields of King Shaka, the famous Zulu king, the twin reserves of Hluhluwe-Mfolozi are renowned for the preservation of black and white rhinos during a time when they were threatened by extinction. Nearby Lake St Lucia is an important wetland and the adjacent coastal forest and beaches (where loggerhead and leatherback turtles come to lay their eggs) are encapsulated in the vast iSimangaliso Wetland Park, which is a World Heritage Site. The Ukahlamba Drakensberg Park is also a World Heritage Site, with the spectacular scenery, crystal clear mountain streams and high-altitude hikes making it a favourite holiday destination.

The Midlands – centred around towns such as Howick and Nottingham Road – offer leisurely drives on country roads, beautiful waterfalls and welcoming towns where potters and painters sell their wares.

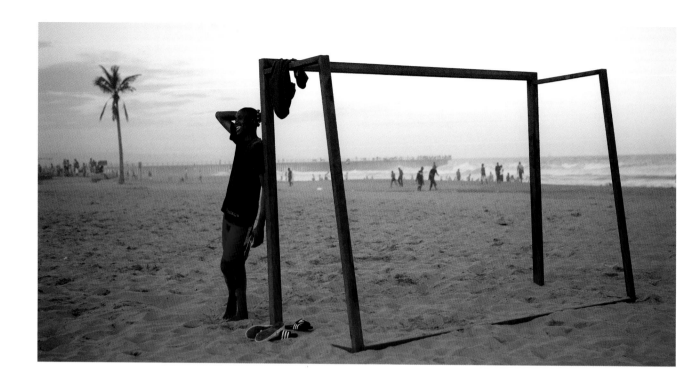

ABOVE: Beach soccer on the Golden Mile, Durban.

RIGHT: Durban is one of South Africa's premier surfing destinations.

Historically, from when Boer farmers moved into the area bordering the Zulu kingdom in the 1830s until the British arrived to stake their claim, clashes between the Boers and the Zulu, the Zulu and the British Empire and eventually the Boers and the British (during the Anglo Boer War of 1899–1902) were frequent. Some of the most famous of these battle sites such as Rorke's Drift, Isandlwana, Spioen Kop and Blood River offer a poignant reminder of those times.

Durban is the biggest city in the province and has a warm climate, vibrant nightlife and legendary beaches. The beaches continue all the way down the south coast of the province – the towns of Margate, Scottburgh and aManzimtoti are all popular destinations.

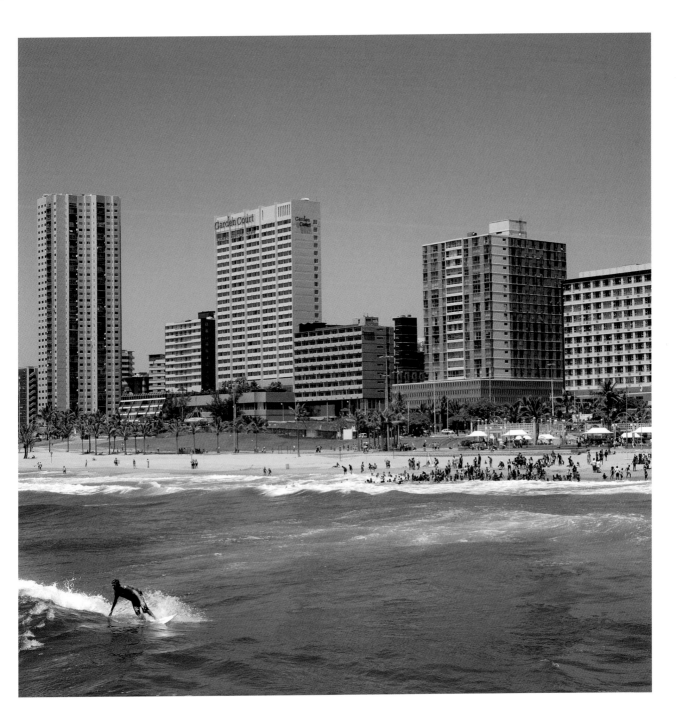

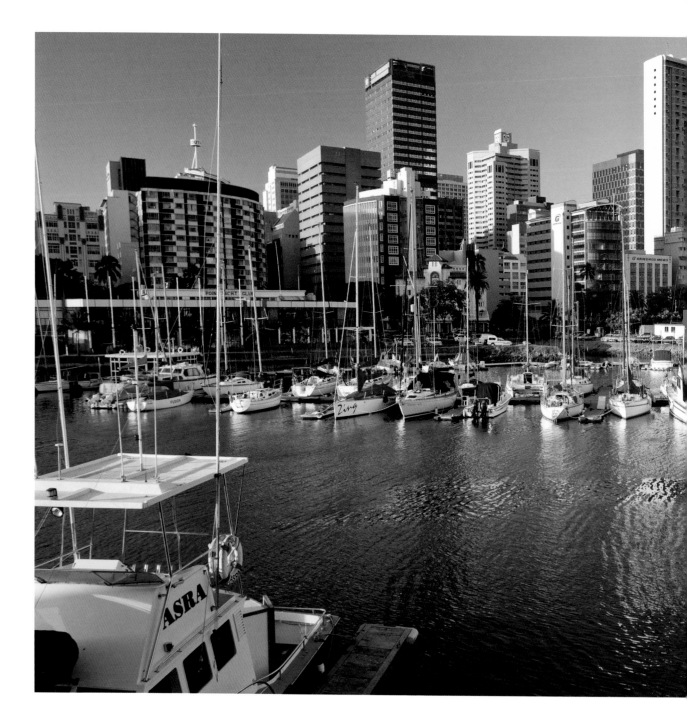

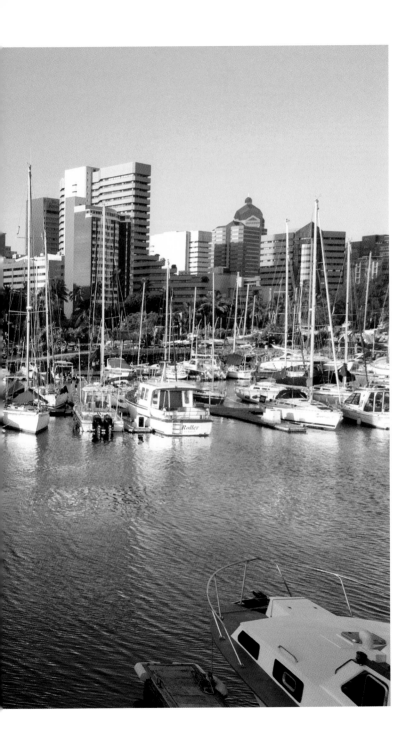

LEFT: The Royal Natal Yacht Club in the Durban harbour was founded in 1858 and is the oldest yacht club in South Africa.

LEFT: A trader mixing her spices at the Victoria Street Market. Durban's large Indian community has its origins during the late 1800s when the British colonial government brought in thousands of Indian indentured labourers to work on the sugar cane plantations.

PAGE 116: Cattle graze near the Injasuti camp in Giant's Castle, part of the Ukahlamba Drakensberg Park.

PAGE 117: Zulu women and children in a rural area outside the town of Melmoth.

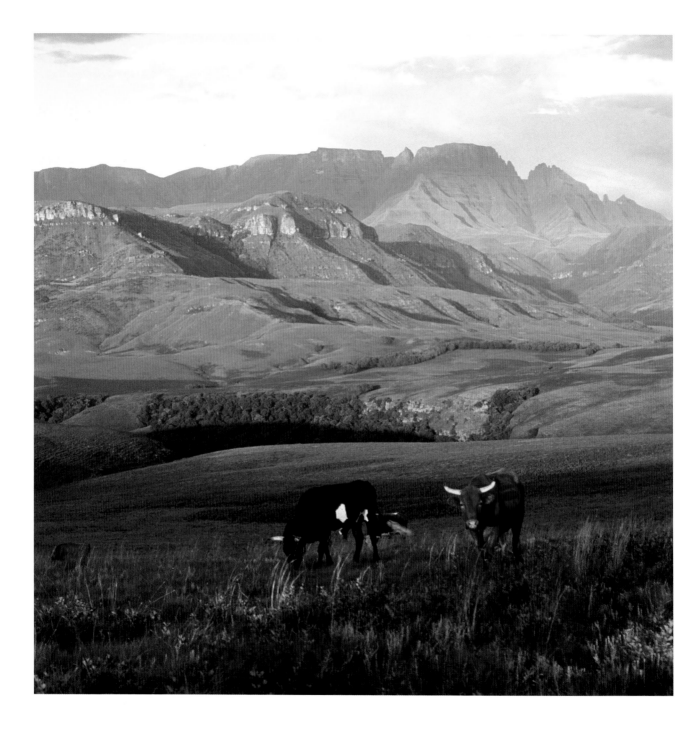

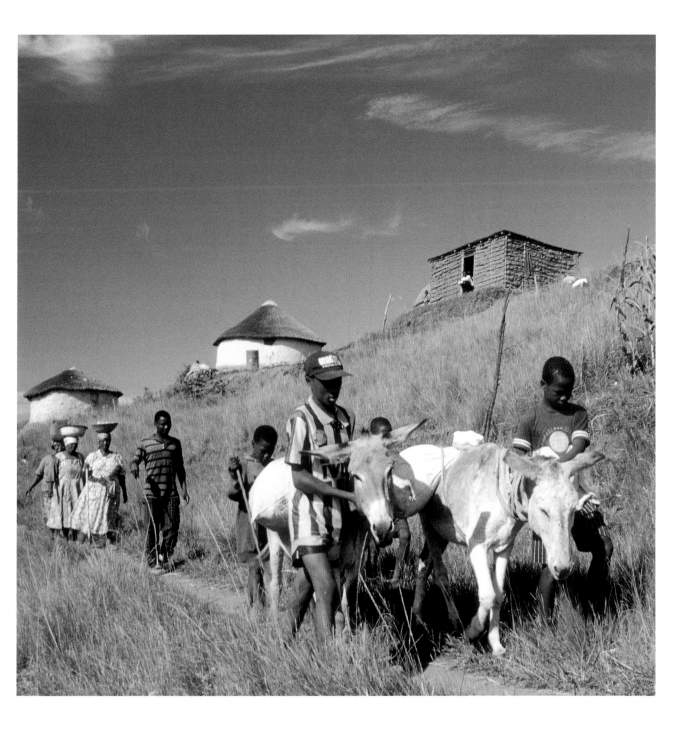

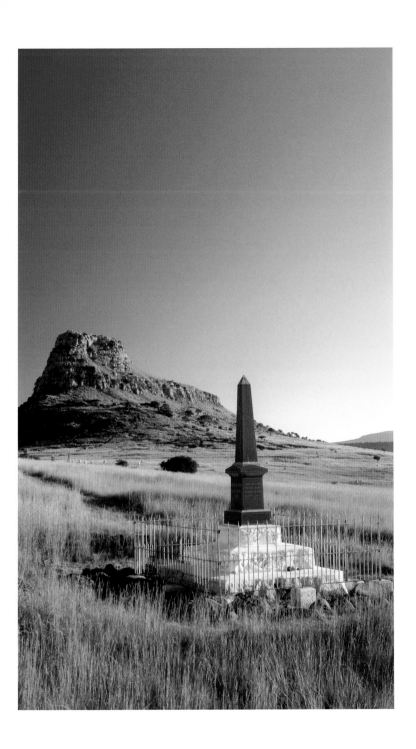

LEFT: The British Imperial Army suffered one of their heaviest defeats of the Anglo-Zulu War at Isandlwana in 1879.

FAR LEFT: The Valley of a Thousand Hills is the heartland of the Zulu people and stretches from KwaMashu north of Durban to near Wartburg.

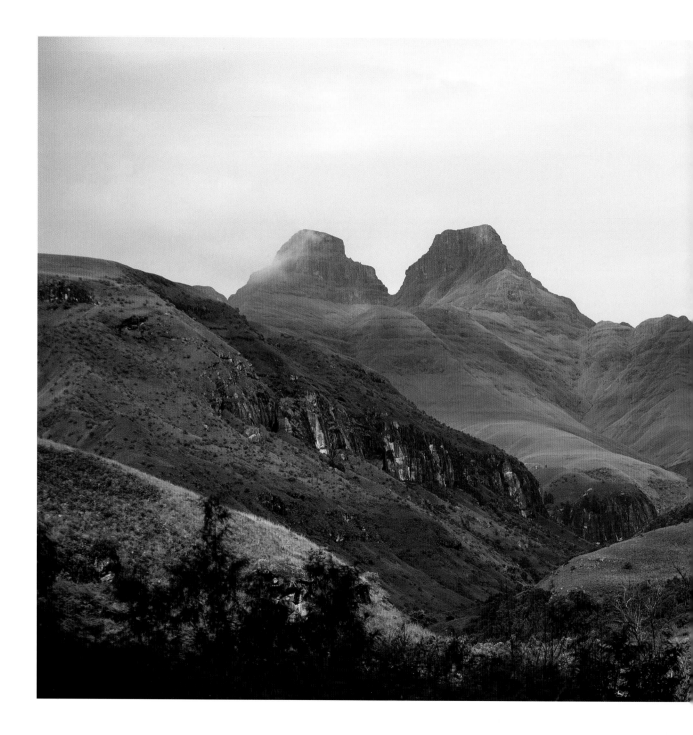

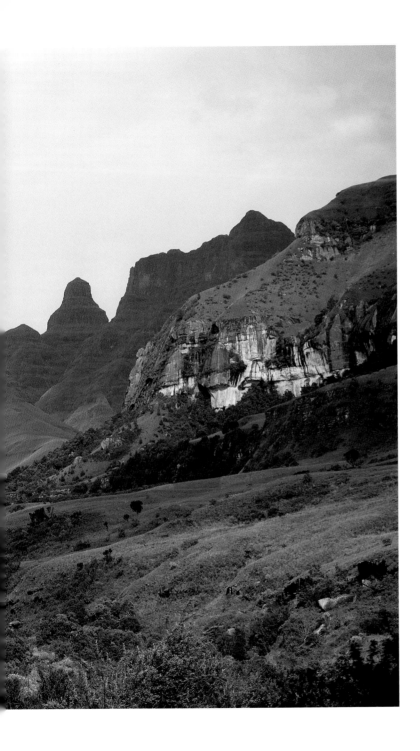

LEFT: The Drakensberg is a haven for hikers, nature lovers and those in search of peace and quiet.

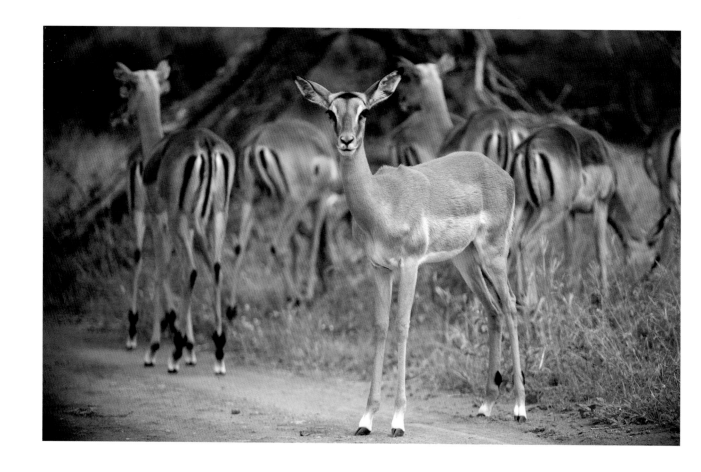

THIS SPREAD: Impala (above) and white rhino
(opposite) are easy to see in the Hluhluwe-Mfolozi
Game Reserve.

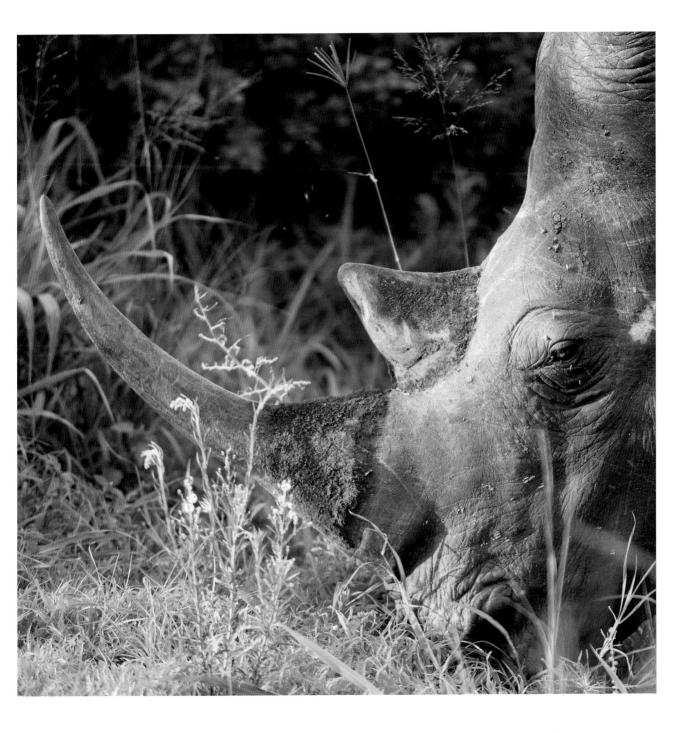

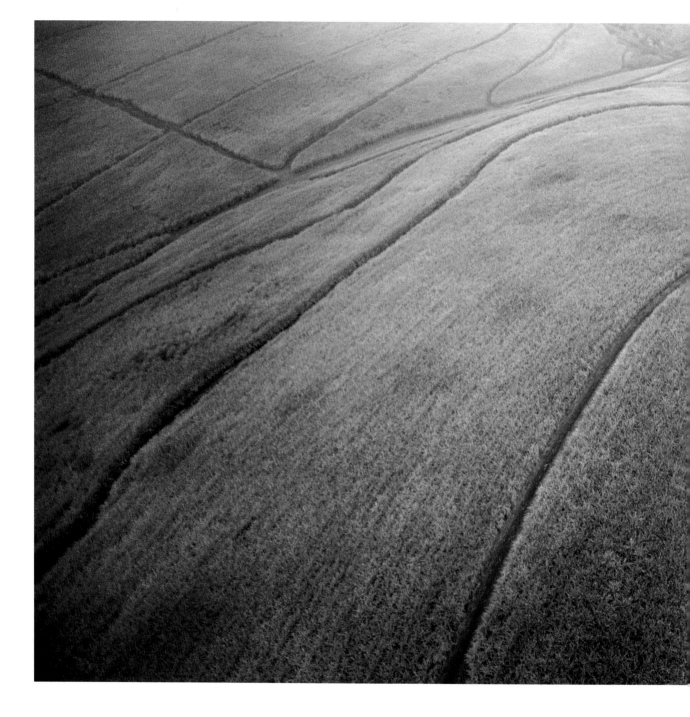

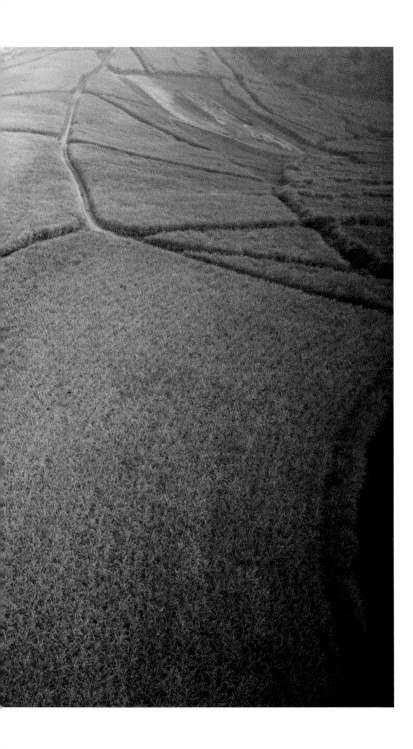

LEFT: Sugar cane is one of the most important crops in KwaZulu-Natal.

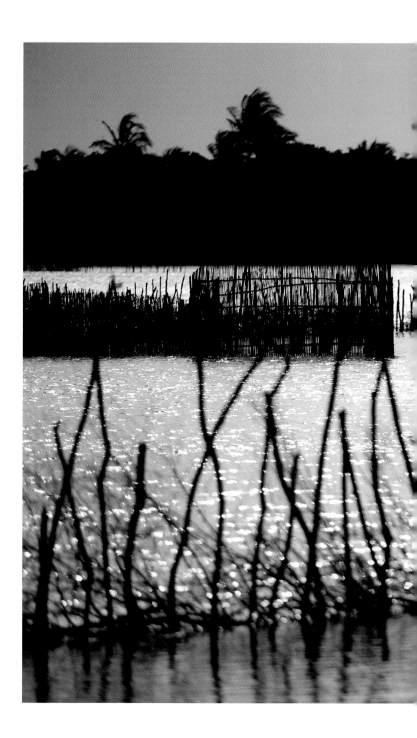

RIGHT: Traditional fish traps in the shallows of
Kosi Bay in Maputaland, northern KwaZulu-Natal.

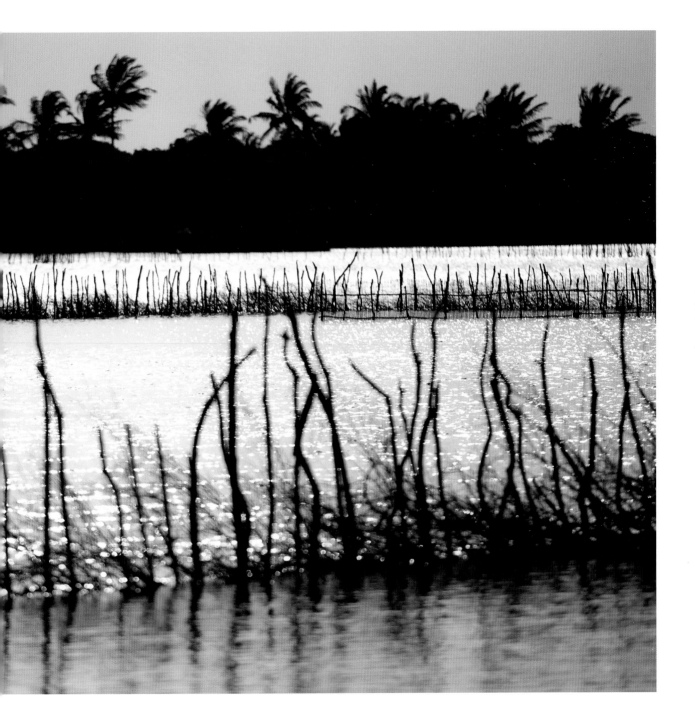

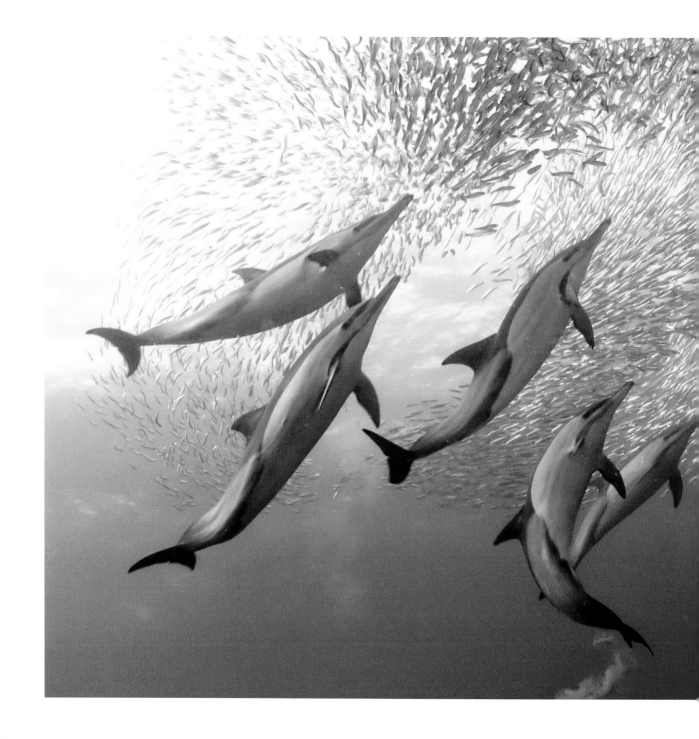

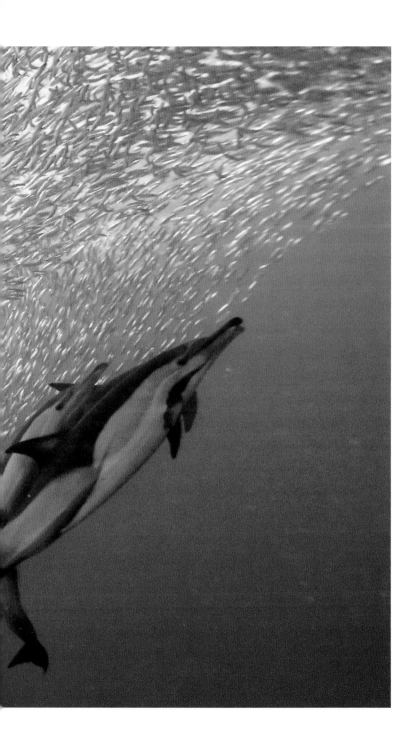

LEFT: A pod of common dolphins encircle a shoal of sardines during the annual sardine run off the southern coast of KwaZulu-Natal. Shoals of sardines are also pushed into the shallows where they are scooped up by the bucketful. The sardine run usually takes place between May and July, and shoals can be up to 7 km in length.

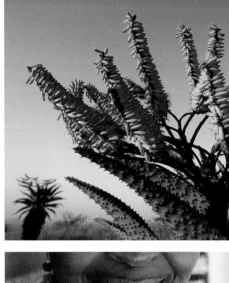

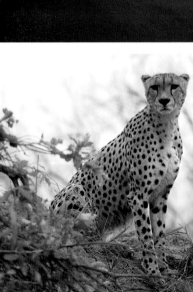
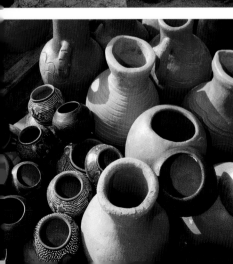

Mpumalanga

At first it might appear as if some of Mpumalanga's landscape is a continuation of the Highveld of neighbouring Free State and Gauteng, but once the industrial towns of Witbank and Middelburg (where much of South Africa's electricity is generated from coal) and their surrounding countryside of rolling grasslands, bird-rich wetlands and cultivated fields have come and gone, things change dramatically.

The land falls away as the Drakensberg escarpment is cleared, revealing the lusher, wetter and warmer Lowveld below, which stretches all the way to the border with Mozambique in the east.

The Lowveld is Big Five country par excellence, with world-class private reserves such as Londolozi and Sabi Sand bordering on the southern section of the Kruger National Park. The Big Five – lion, elephant, leopard, rhino and buffalo – were not named simply for their size (after all, hippos and giraffes would then surely also qualify!), but for how dangerous they are.

The Kruger is South Africa's biggest game sanctuary (it is almost the size of Israel) and was officially opened to visitors in 1927. The park's southern half is in Mpumalanga province and the northern half in Limpopo. It is named after Paul Kruger, who was president of the Transvaal (the South African Republic).

Besides the opportunity to get close to elephants and lions, Mpumalanga also offers some of South Africa's finest scenery. Along the Drakensberg escarpment just north of the town of Graskop lie the Three Rondavels (hut-shaped buttresses), the Blyde River Canyon's gaping green valley and waterfalls such as the Berlin and Lisbon Falls. One can look down onto the

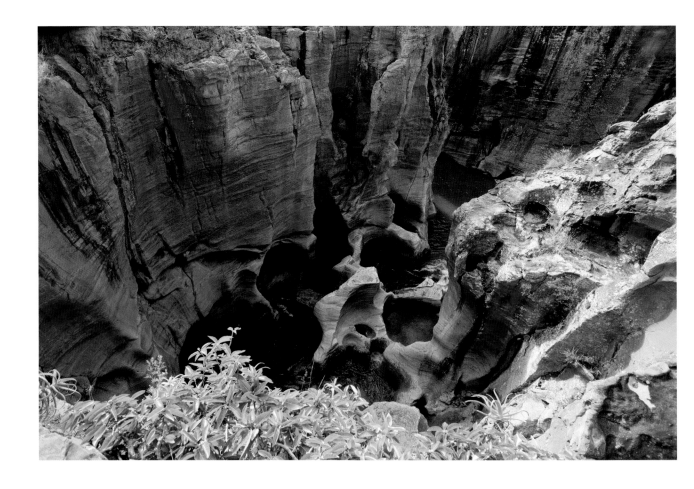

ABOVE: The Bourke's Luck potholes were formed by centuries of water erosion. The Treur and Blyde rivers have their confluence here.

RIGHT: The Horseshoe Falls are hidden in the forests at the foot of the Long Tom Pass outside the town of Sabie.

Lowveld from numerous enchanting viewpoints with names such as God's Window and Wonder View that line the escarpment here.

There are many mountain passes too, such as Long Tom Pass (named after a cannon that saw action in the Anglo Boer War), Kowyn's Pass and Robber's Pass, which got its name during the gold rush at nearby Pilgrim's Rest during the late 1800s when coaches were regularly robbed along this route. Further south, near the border with Swaziland, Barberton still yields gold to this day.

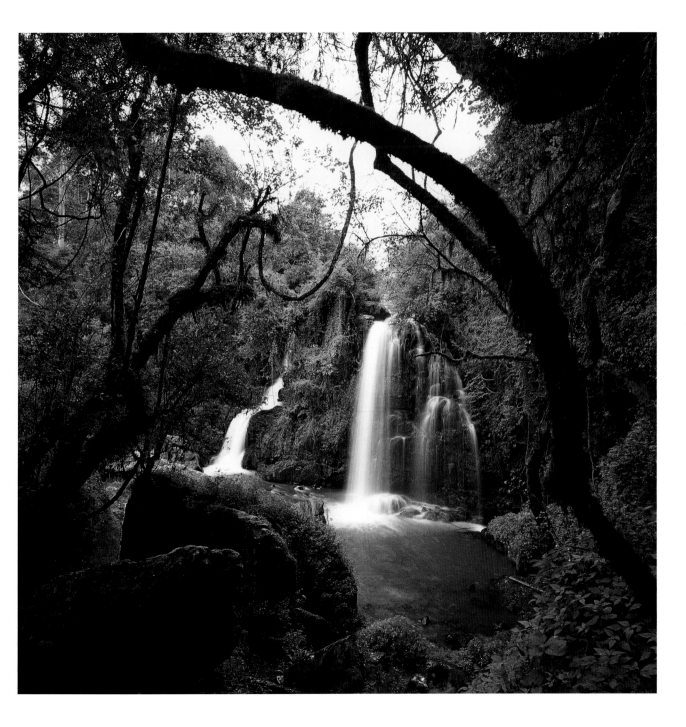

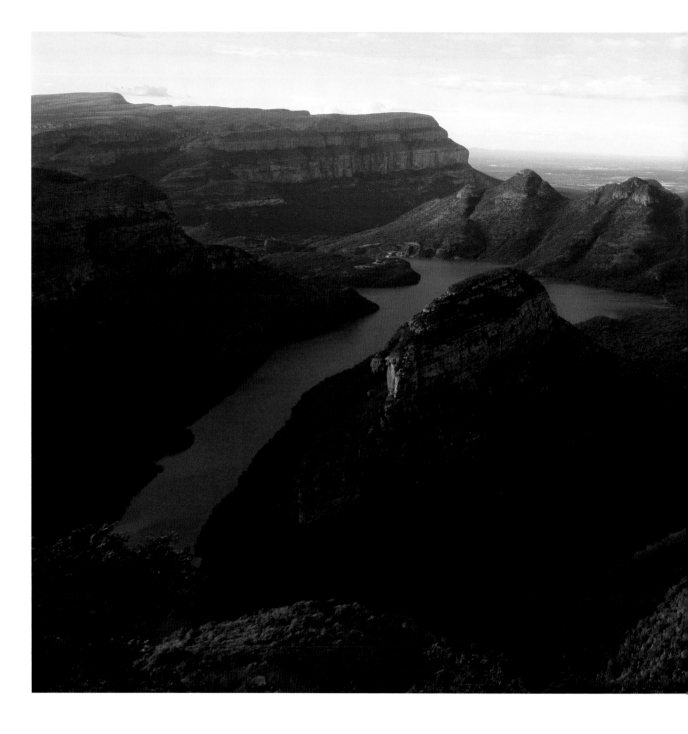

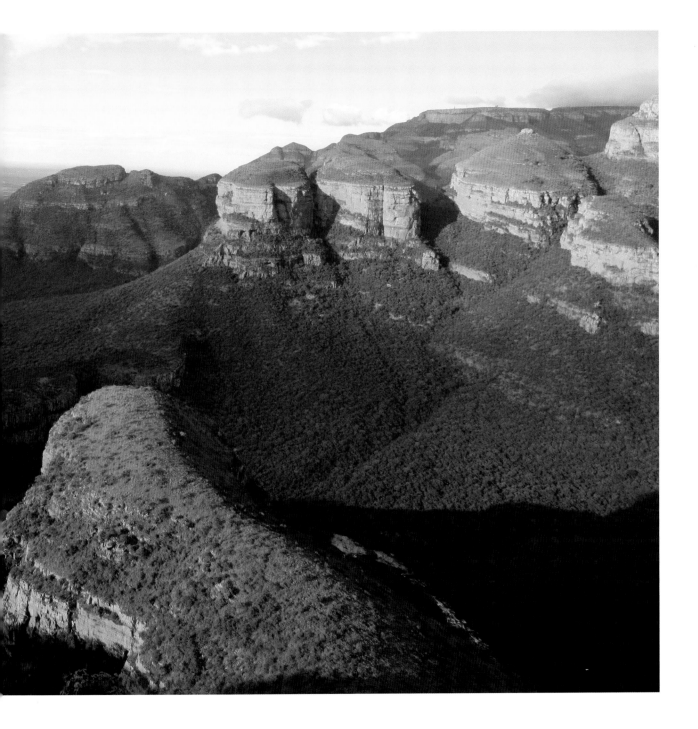

PREVIOUS SPREAD: The Blyde River Canyon with the Blydepoort Dam at left, the Sundial hillock in the centre and the Three Rondavels at right. The mountain in the distance on the right is Mariepskop, 1 944 m high.

RIGHT: After harvesting, round bales are made, which can be used for winter livestock feeding purposes. This farm is in the Highveld of Mpumalanga.

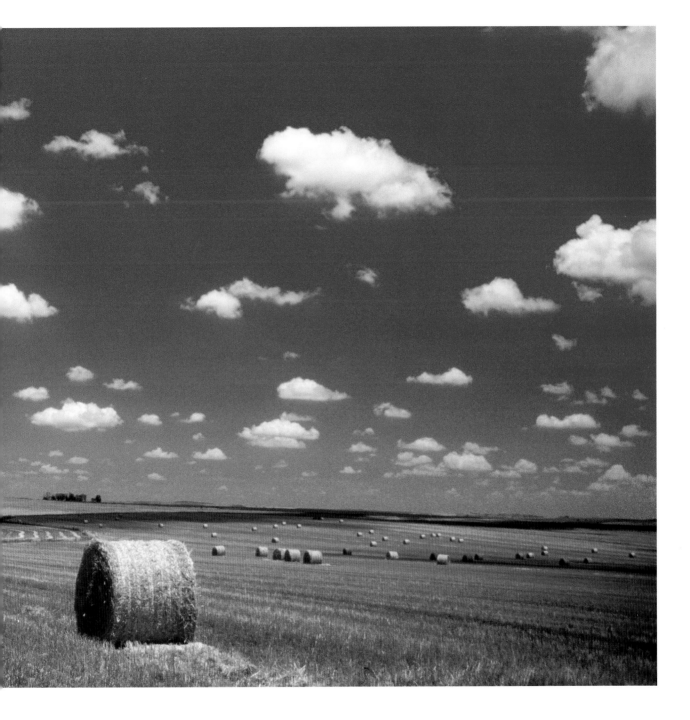

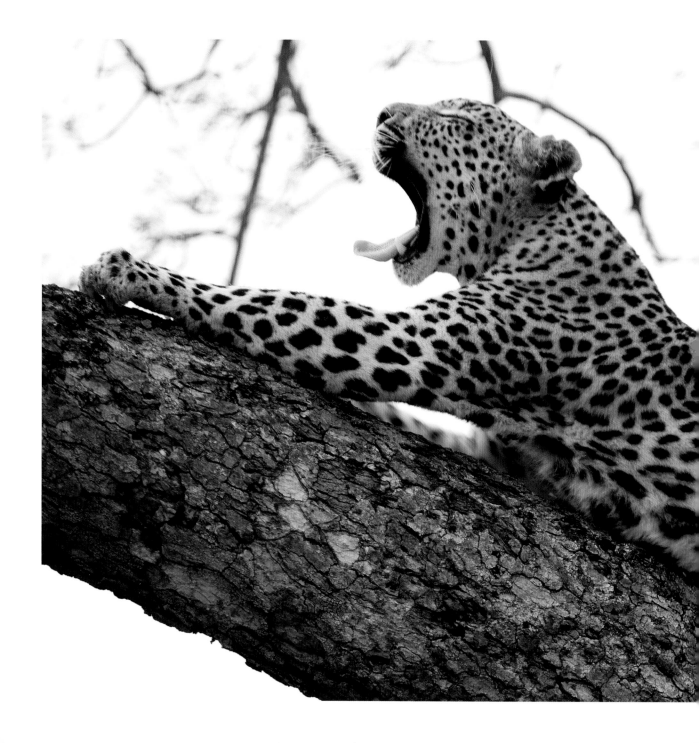

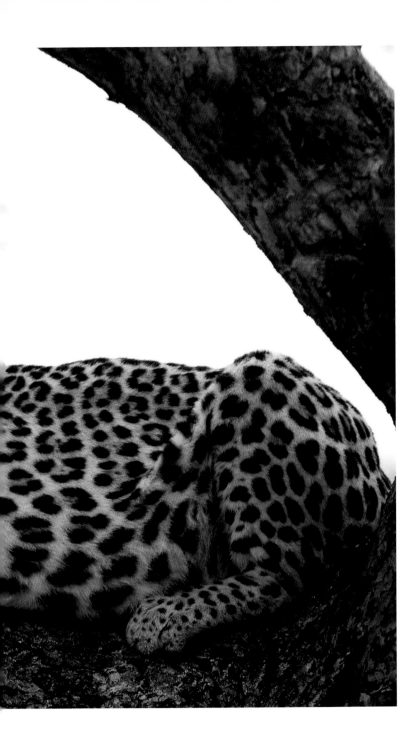

LEFT: A leopard stretches out in Londolozi Game Reserve. Besides having heavier, sturdier bodies, leopards can easily be distinguished from cheetahs by their rosette-shaped spots. Cheetahs have simpler spots. Leopards often drag their kill up into trees to keep it away from other predators such as lions and hyenas.

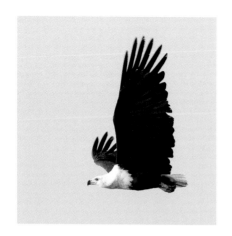

ABOVE: The African fish eagle's call is one of the most distinctive sounds of the South African wilderness.

RIGHT: Adult giraffes can grow to a height of more than five metres and weigh over a ton.

FAR RIGHT: Plains zebra (previously known as Burchell's zebra).

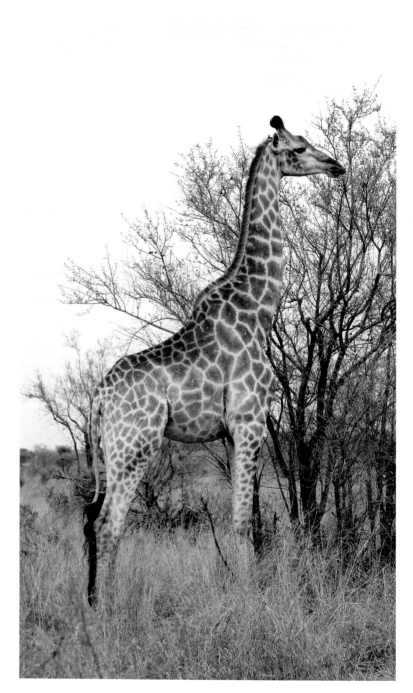

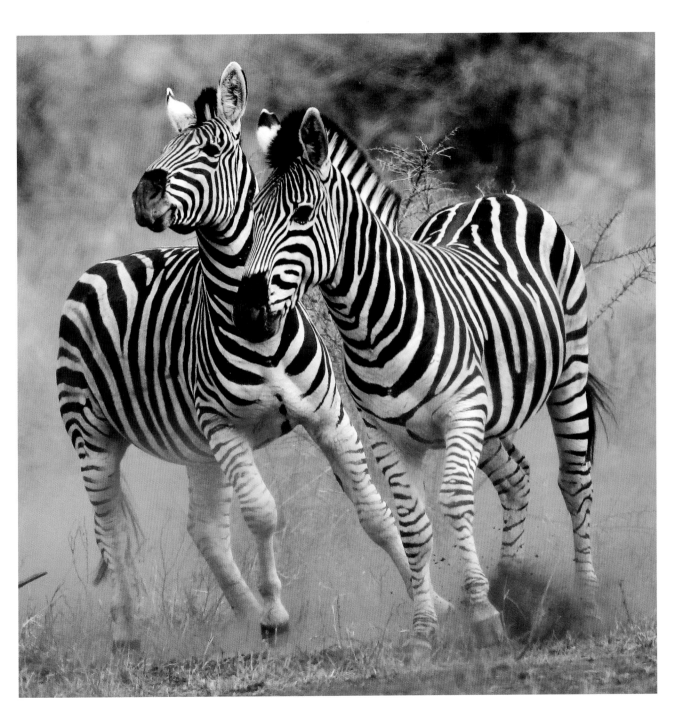

RIGHT: Trout fishing is popular in the high-lying district of Dullstroom.

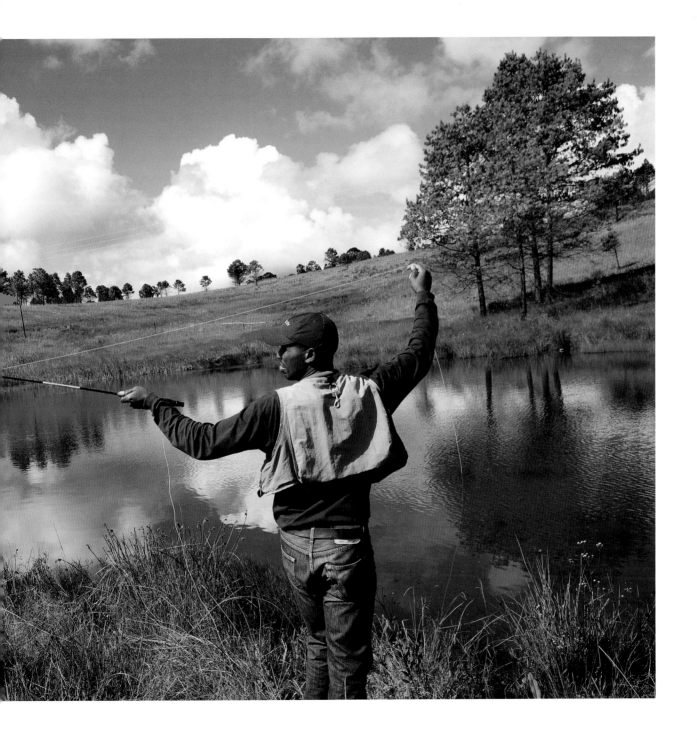

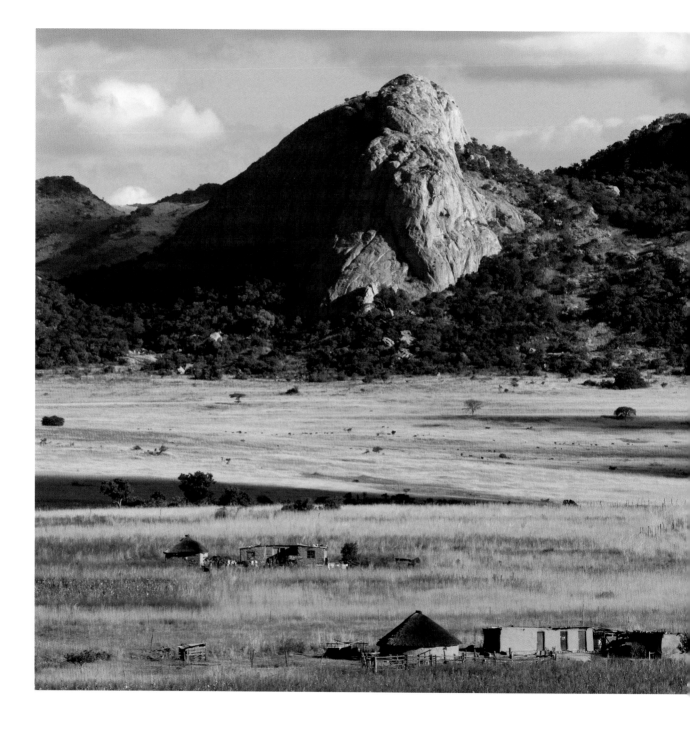

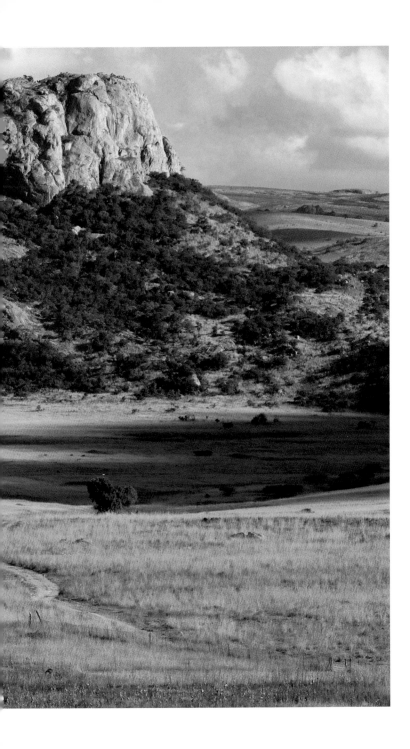

LEFT: A rural homestead near Badplaas. Rocks in the district have been dated as among the oldest in the world.

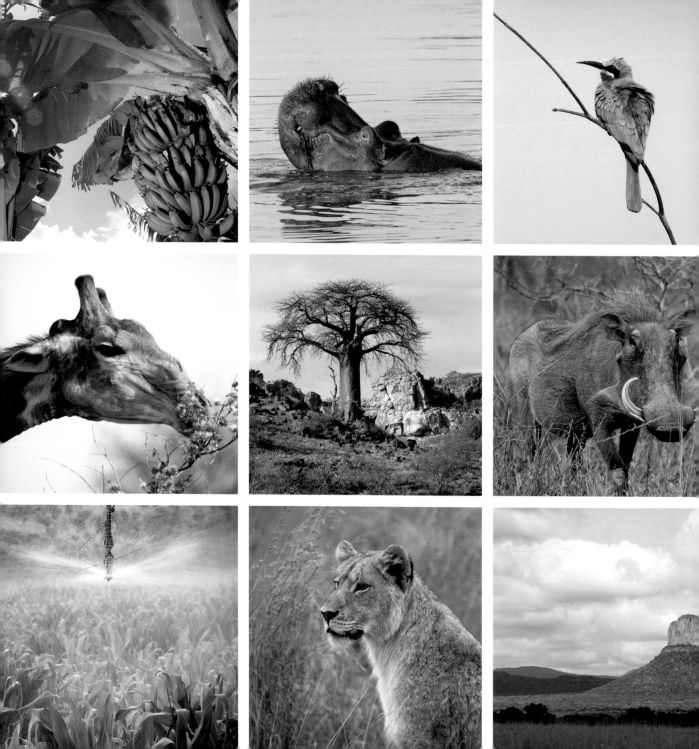

Limpopo

The northernmost of South African provinces, Limpopo is home to large parts of the bushveld, an area typified by its characteristic vegetation of tall thorn trees, the more shrub-like sickle bush that grows in dense thickets and open patches of tall grasses such as tambuki.

The bushveld holds a mythical appeal to lovers of the great outdoors, with many a South African tall tale birthed around a bushveld campfire. With its small private reserves and lodges and larger national parks, Limpopo draws those visitors who would like to experience this almost frontier-like quality.

Wildlife is abundant, with the northern half of the Kruger National Park extending into the province. While Marakele National Park is not short on big game, it is perhaps best known for its large breeding colony of the endangered Cape vulture, which calls this part of the Waterberg mountain range home.

The major mountain ranges of the province are the Waterberg, the Soutpansberg (in the far north) and the Drakensberg in the east, which is also the limit of the bushveld's reach. The Wolkberg and Magoebaskloof are two particularly scenic mountainous areas of the province, and the rainfall is higher here resulting in lusher vegetation and enormous trees.

On the Limpopo River, which forms a natural border to the north with Botswana and Zimbabwe, lies Mapungubwe, a World Heritage Site, which was the centre of a kingdom that reached its height in the 13th century.

Besides tourism, game farming and mining (half of the richest platinum reserve in the world falls within the province),

OPPOSITE FROM LEFT TO RIGHT:

- A banana grove, Tzaneen.
- Despite their cute looks, hippos are among the most dangerous mammals in Africa.
- White-fronted bee-eaters mate for life and make nests by burrowing into river banks.
- Giraffes have tough tongues that allow them to nibble the leaves on thorny twigs.
- Baobab tree, Mapungubwe.
- A big warthog boar.
- Maize under irrigation near Mookgophong.
- Female lions do most of the hunting in a lion pride.
- Olifantskop hill stands above typical bushveld in the eastern Waterberg.

A thousand years ago, Mapungubwe was the capital of an African kingdom with trade links reaching all the way to China. A gold rhino statuette discovered here in 1933 is one of South Africa's most treasured cultural artefacts.

RIGHT: The Waterberg escarpment in the Marakele National Park.

crop farming, such as cotton and maize, occurs in the southern parts of the province near Bela-Bela in an area known as the Springbok Flats.

Bela-Bela's previous name was Warmbaths, named after the hot springs that bubble to the surface here. A large resort at the springs has lured visitors here for many years. Another hot springs resort lies at Tshipise, between the border town of Musina and Thoho-yandou, capital of the former homeland of the Venda people.

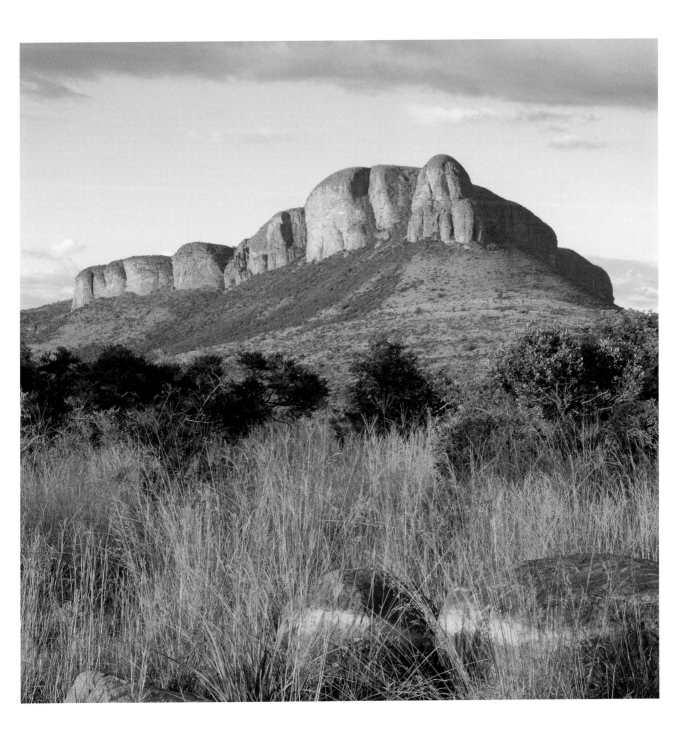

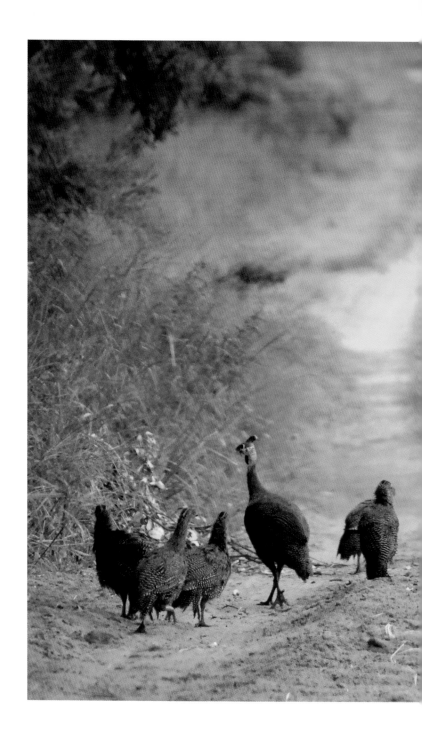

RIGHT: Guinea fowl in the road close to a bush camp on Mabote farm, Waterberg.

FOLLOWING SPREAD: Sunrise over the Olifants River, Kruger National Park.

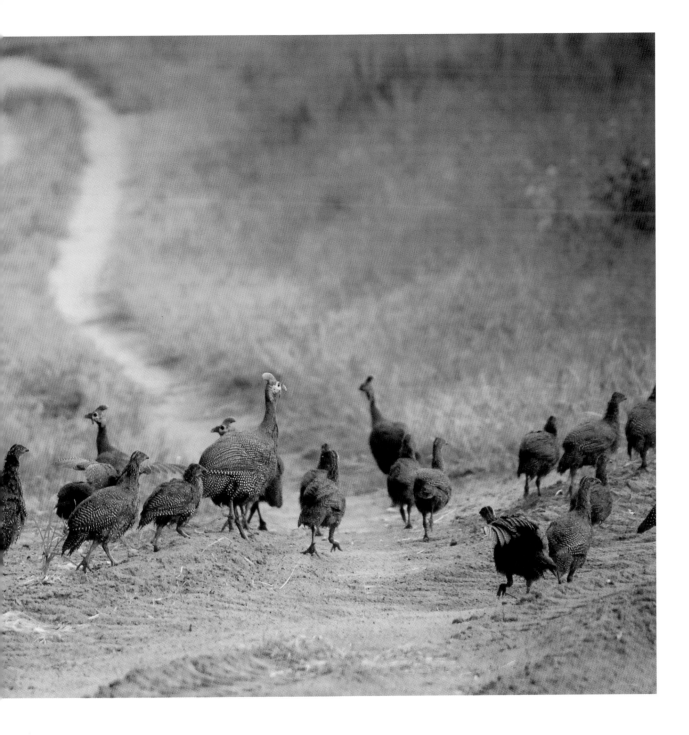

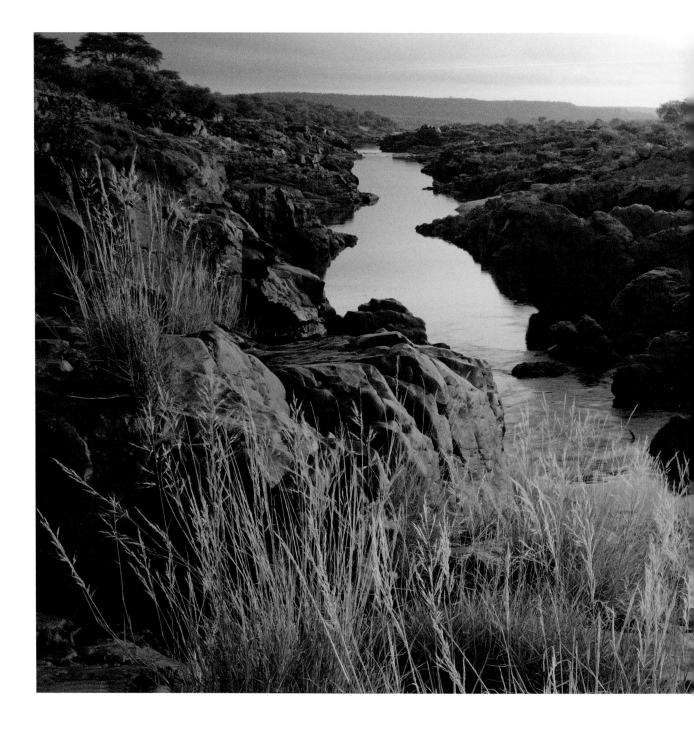

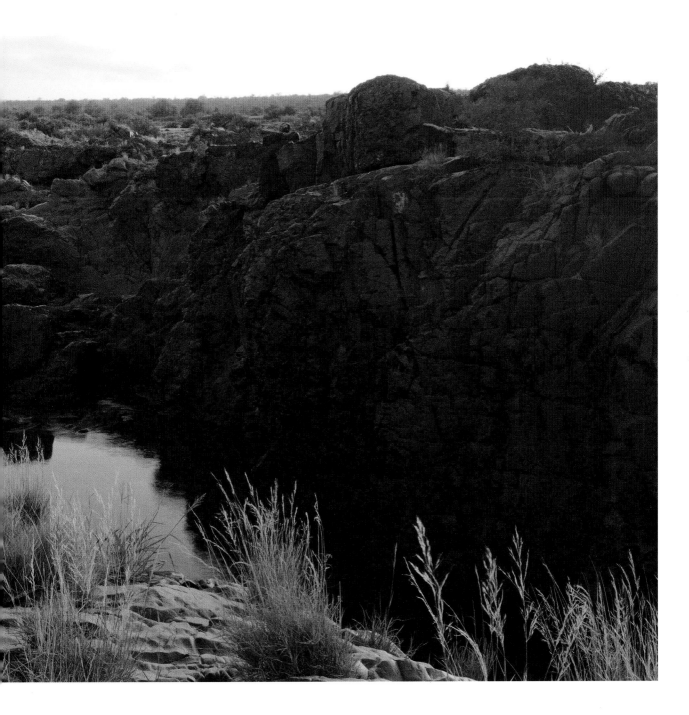

RIGHT: Yellow-billed storks can usually be seen in the Kruger National Park throughout the year, but they also migrate to other parts of the country outside of breeding season. Their diet includes fish, fresh water crabs and insects.

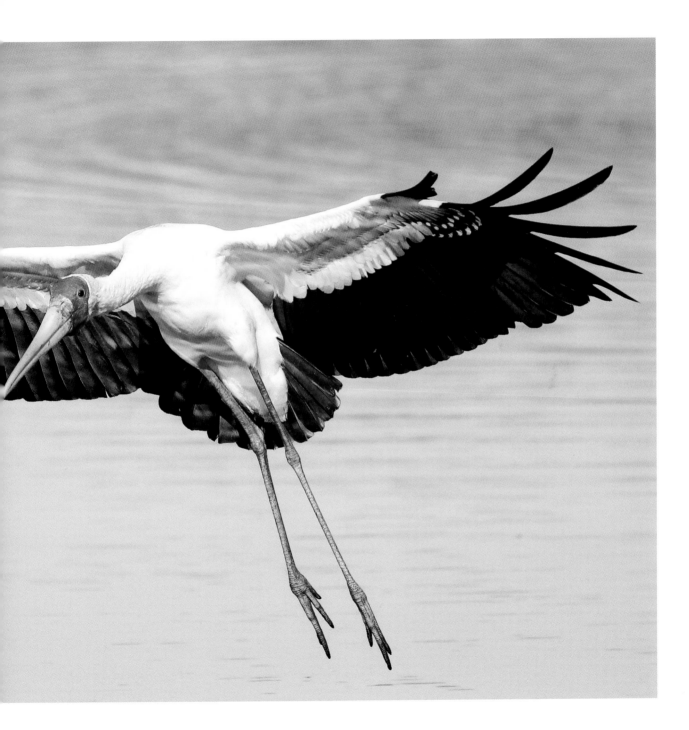

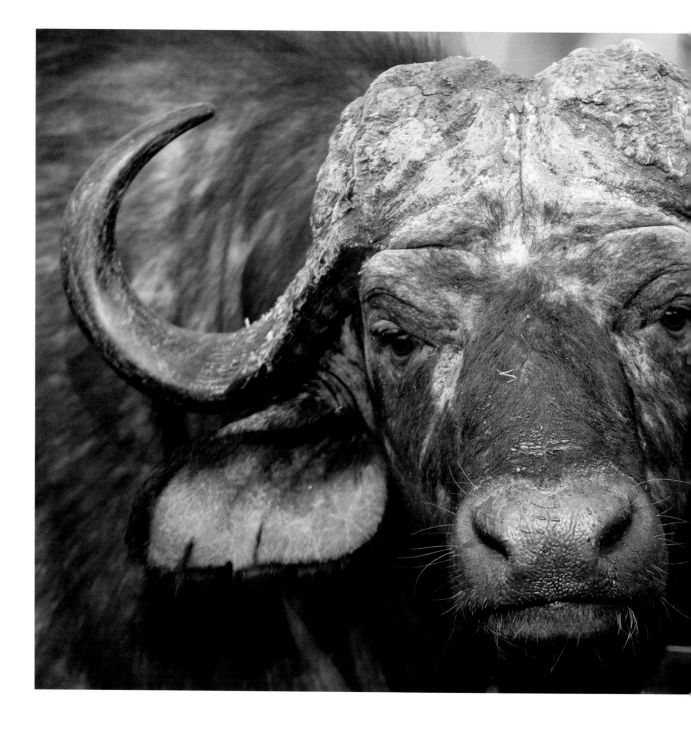

LEFT: Cape buffaloes (*Syncerus caffer*) are notoriously moody animals and have not been successfully domesticated like Asian buffalo. In the Kruger National Park, herds sometimes number a couple of hundred animals.

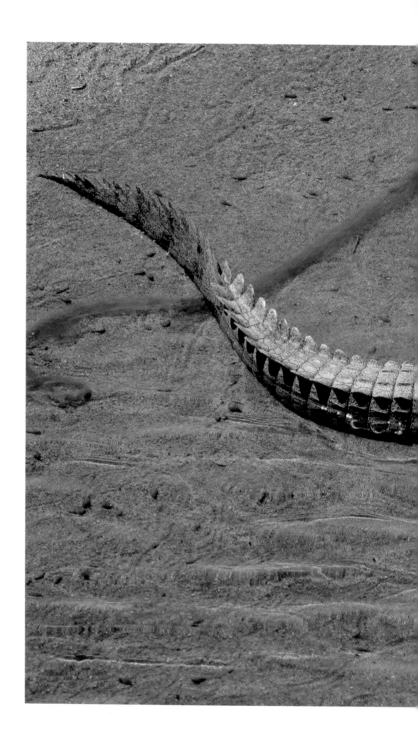

RIGHT: Nile crocodiles can grow up to five metres long.

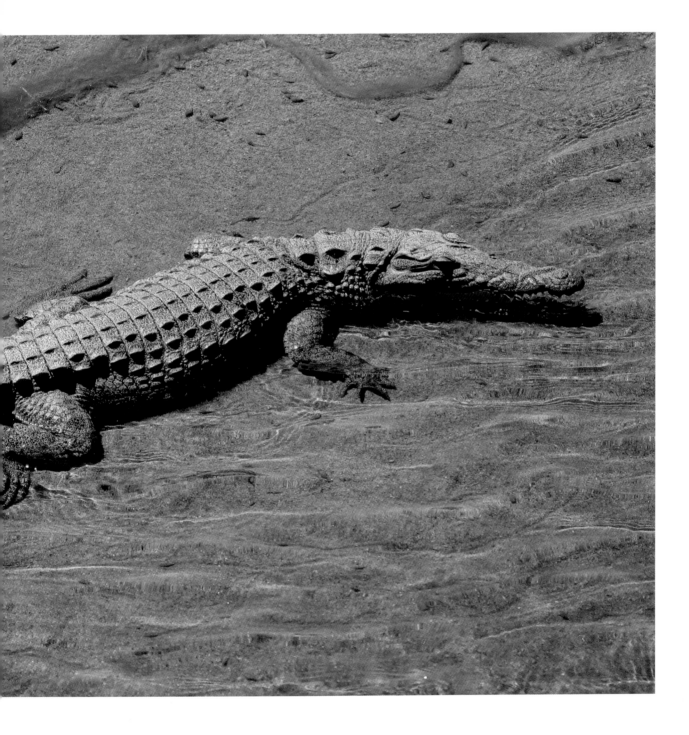

First published in 2010 by

Sunbird Publishers (Pty) Ltd

(an imprint of Jonathan Ball Publishers (Pty) Ltd)

Registration number: 1984/003543/07

PO Box 6836

Roggebaai 8012

Cape Town, South Africa

www.sunbirdpublishers.co.za

Publisher: Ceri Prenter

Cover, design & typesetting: MR Design

Reproduction: Resolution, Cape Town

Printing and bound by Tien Wah Press (Pte), Singapore

ISBN 978-1-92028-911-9